CONCILIUM

concilium 1994/1

VIOLENCE AGAINST WOMEN

Edited by

Elisabeth Schüssler Fiorenza and M. Shawn Copeland

SCM Press · London

Orbis Books · Maryknoll

Published by SCM Press Ltd, 26–30 Tottenham Road, London N1
and by Orbis Books, Maryknoll, NY 10545

ISBN: 0 334 03024 2 (UK)
ISBN: 0 88344 876 9 (USA)

Typeset at The Spartan Press Ltd, Lymington, Hants
Printed by Mackays of Chatham, Kent

Concilium Published February, April, June, August, October, December.

Contents

Introduction

This issue of *Concilium* on Violence Against Women documents and explores the death-dealing powers at the heart of patriarchal and kyriarchal[1] relations of oppression. Violence against women and their children is all-pervasive. It is not limited to one specific class, geographical area or type of persons. Rather, it cuts across social differences and status lines. White, black, rich, poor, Asian or European, Hispanic or Anglo, urban or rural, religious and secular, professional and illiterate, young and old women face daily violence because of their gender.

In a poem published more than twenty years ago the African American writer Ntozake Shange has summed up this life-threatening danger in which women of all classes, races, religions and cultures daily find themselves.

> Every three minutes a woman is beaten
> every five minutes a
> woman is raped/every ten minutes
> a little girl is molested . . .
>
> every day
> women's bodies are found
> in alleys and bedrooms/at the top of the stairs . . .[2]

Charting the problem

In the intervening years feminist work has documented and analysed the multifarious forms of violent attacks against women just because they are women.[3] The list of abuse is endless: child-pornography, sexual harassment in schools and jobs, sex-tourism in Asia, Latin America and Africa, trafficking in women, sexual and domestic bondage,[4] gender-specific violations of human rights,[5] lesbian bashing, right wing neo-Nazi terror

against women, mutilation and stoning of women on grounds of infidelity, restriction of movement and exclusion from the public sphere, Purdah[6] in its various forms, sati in India, sexual assault in the workplace, rape in war[7] and peacetime, women refugees and displaced persons, maids and migrant workers,[8] illiteracy, poverty, forced prostitution, child prostitution, wife bartering, female circumcision, eating disorders, psychiatric hospitalization, battered women and children, incest and sexual abuse, homelessness, silencing of women, negation of women's rights, HIV infection through husbands, dowry death, isolation of widows[9] and older women, abuse of the mentally ill, emotional violence, cosmetic surgery, cultural marginality, torture, strip search and imprisonment, female infanticide, witch burning, foot binding, rape in marriage, date rape, food deprivation, serial murder, sado-masochism, genital mutilation . . .

Most of these atrocities are part of women's daily lives around the globe. When asked what was the worst aspect of being female, participants in a twelve-country workshop held in China unanimously pointed to male violence.[10] Such violence can take many forms: In the US more than two million women have received breast implants, and the number of women who have 'chosen' cosmetic surgery has increased more than 60% in the past decade.[11] In Africa more than 84 million women have undergone sexual surgery according to the World Health Organization.[12] Iranian women who show their 'shameless nakedness' by appearing in public without being completely covered are held punishable by seventy-four lashes without a court hearing, spat upon, attacked with knives and guns, and are fortunate if they survive the experience.[13] Nevertheless, the malestream news media seldom report such crimes against women. For instance the collective rape of women in Bosnia executed in the interest of ethnic cleansing has only been reported by the international media after feminist publications pointed to this scandal. The widespread use of rape by government and guerrilla forces in the North Indian state of Cashmere or the trafficking in Burmese women and girls continues to escape the spotlight of the international press.[14]

Femicide,[15] the murder of women, is the deadly outcome of such violence. Most women around the world are murdered in their homes by men with whom they have shared daily life. In the US nine out of ten women murdered are killed by men known to them; four out of five are murdered at home.[16] For example, of the seventy-three women murdered between 1975 and 1979 in Dayton, Ohio, 80% knew their killers intimately as husbands, friends, family members, prior sex partners, acquaintances.

Fully 72% of the women were killed in their homes.[17] Such violence against women and its often deadly outcome is not restricted to the so-called First World, but similar statistics are found around the globe.[18] For instance, 80% of women in Santiago, Chile have suffered sexual, emotional or physical abuse by a male partner or relative. 50% of all murders in Bangladesh are of wives killed by their husbands. Some 2,000 Asian maids have fled from the abusive employers in Kuwait since the end of the Gulf War. Two-thirds of the women who survived the ordeal have reported that they have been kicked, locked up, raped, beaten and mutilated by their male employer or his male relatives.[19] In the US, battering is the single greatest cause of deadly injury to women. Its impact is greater than muggings, car accidents and rapes combined. The majority of women and children who were killed in the metropolitan area of Boston in the first quarter of 1993 were murdered by husbands or live-in partners, although they had asked the police for help and even had obtained restraining orders.

Since December 1991 the German feminist journal *Emma* has documented that the most dangerous place for Western women is not the street but the privacy of the home, by chronicling the deadly violence against women.[20] Typical entries in this 'Chronicle of Hate' are: 1 February 1993, Villingen-Schwenningn, woman, 28, shot by her husband; 6/7 February, Augsburg, woman, 55, knifed in her sleep by her son; 16 February, Frankfurt, woman battered to death with a walking-stick by her husband; 18 February, Cologne, woman, 55, strangled by the ex-boyfriend of her daughter; 18 February, Mannheim, woman, 44, killed with scissors by her live-in partner; 19 February, Düren, nurse, 22, raped and killed on her way to work by former patient; 9 March, Kassel, Afghan woman, 25, killed with bread knife by her brother; 20 March, Landringhausen, woman, 51, choked to death by her husband; 20 March, Cologne, woman, 44, died of knife wounds inflicted by her son; 27 March, Kaltenkirchen, woman, 34, killed with an axe by her husband after marital quarrel; 27 March, Essen, woman, 37, drowned by her husband; 4 April, Kiel, woman, 34, strangled, alleged murderer: boyfriend; 5 April, woman, 72, stabbed to death by her son.[21]

In December 1989 Marc Lépine killed fourteen college engineering students at the University of Montreal in Canada. He gave as reason for his action that they were 'fucking feminists'. Press reports speculated that he harboured such hatred for women probably because he had experienced intense humiliation by women, especially at the hands of a domineering

mother. Whereas this mass murder engendered much speculation in the press, the American media did not report that in January 1993 four women in Somalia were condemned to be stoned to death, a fifth was ordered to receive a hundred lashes as punishment, and a sixth was imprisoned facing the same charges. These women were condemned on grounds of 'prostitution' because they associated with and sought the protection of UN soldiers.[22] Whether Western psychological and journalistic discourses, democratic courtroom hearings, or Eastern religious theocratic laws, none holds perpetrators responsible for practices of victimization but presumes that the women who are victimized by public vilification or acts of crime are to blame. Worse, the victims themselves often have internalized such guilt.

Systemic analysis

However, overt physical and sexual violence must not be seen as isolated incidence or perverse behaviour but must be explored as structural normative practices. Such violence must be placed on a continuum of male power and control over women and children that encompasses not only physical violence but also the cultural and religious construction of docile feminine bodies and subservient feminine selves. Verbal, emotional, economic, political, physical or sexual violence against women must not be reduced either to abstract statistic or to episodic evidence and isolated incidence. Rather, it must be understood and explored in systemic terms.

Whereas in classical patriarchy elite men exercised the power of life and death over freeborn women, children, slaves and servants of their household, in capitalist patriarchal democracy every man is believed to be entitled to exercise physical control and legal power over the women and children belonging to 'his' family, race, class or nation. Personal and national power is expressed through control and violence against women who signify all that is weak. Hence, violence against women is not just generated by heterosexist patriarchal but also by colonialist kyriarchal power.[23] Violence against women constitutes the heart of kyriarchal oppression. It is sustained by multiplicative structures of control, exploitation and dehumanization: the oppressive powers of hetero-sexism are multiplied by racism, poverty, cultural imperialism, war, militarist colonialism, homophobia and religious fundamentalism.

Only if feminist discourses focus on the woman at the bottom of the kyriarchal pyramid will they be able to explore and comprehend all

dimensions of the death-dealing violence against women. Feminist analyses have amply documented how the disciplining practices of culture and religion enact and reenact received gender norms producing the 'feminine' body.[24] For instance, Sandra Lee Bartky has pointed out that three such disciplining socio-cultural practices produce the docile sub-jected and made-up body as the ideal body of 'femininity'.[25] However, I suggest that a fourth type of socio-cultural practices must be investigated, if it should become apparent that the 'feminine' body is not just gendered but also 'raced', 'classed' and religio-culturally typed.

The *first* assemblage of disciplining practices seeks to produce the ideal feminine body as a body of a certain size and general configuration. Its regimes are obsessive dieting in order to produce the slender boyish body as well as forms of exercise that shape the 'ideal' body form. 75% of US women aged 18–35 believe they are fat and 95% of enrollees in weight-loss programmes are women. 90% of all persons with eating disorders are women. Only one in 40,000 women meets the requirements of a model's size and shape, who today weighs 23% less than the average woman. A California study shows that 80% of fourth-grade girls were already dieting, 53% of high school girls are unhappy with their body by age thirteen and 78% by age eighteen. Such a negative body image leads to erosion in self-affirmation and self-confidence of girls as well as to the tendency of women to renounce and devalue their own perceptions, beliefs, thoughts and feelings.[26] Even highly accomplished professional women exhibit such negative self-appraisal and self-worth; they tend to feel 'illegitimate, apologetic, undeserving, anxious, tenuous, out-of-place, misread, phony, uncomfortable, incompetent, dishonest, guilty'.[27]

The *second* set of practices seeks to produce the 'docile' female body by enforcing a specific repertoire of gestures, postures and movements. It constricts women's spatiality and movement. Women's body language must be deferential, timid and subservient. Women are taught that when sitting, walking and speaking they must constrict their gestures and should not 'let themselves go' in public so as not to give the impression of being a 'loose woman'. Such a restriction of movement in the name of 'graceful' behaviour is reinforced through clothing (e.g. high-heeled shoes) and certain forms of etiquette (e.g. not to spread one's legs when sitting). Through their clothing, movements, gestures and smiles women must communicate that they are 'nice', unthreatening and subservient, in short that they are 'feminine'.

The *third* set of practices is directed towards the display of the body as an ornamental surface. Women's faces and bodies must be made up and made over according to normative standards of beauty. These normative standards of beauty are Eurocentric and racially biased. The blonde, blue-eyed white Barbie doll communicates such a racist standard of 'femininity'. Hair must be straightened or curled, facial and bodily hair must be excised. Early on women have to become skilled in numerous techniques of hair care and skin care, practise the narrowly circumscribed 'art' of cosmetics, and suffer cosmetic surgery so that the 'properly' made-up woman can appear in public. Conformity to the prevalent standards of 'feminine' dress and make-up is a prerequisite for well-paying jobs and social mobility. No wonder that cosmetics are a $20 billion industry world-wide. In the US the cosmetic surgery industry grosses $300 million a year and has increased 61% over the last decade.

A *fourth* set of practices is directed towards shaping the feminine body as a cultural-religious symbol. It seeks to produce the 'feminine' body as the ideal body by inflecting the first three types of disciplinary practices in terms of race, culture, class and religion. On the one hand, such inscriptions of the body seek to produce the submissive feminine by inculcating the desirability of the hegemonic feminine. Again and again womanist scholars have pointed out that beauty standards are not just sexist but also racist. The American ideal of beauty glamourizes elite, young white women's features and bodies. The self-esteem of African-American women is undermined by colourism or pigmentocracy which highly prizes light skin and 'good hair', i.e. not 'kinky hair'.[28] Moreover, this 'politics of beauty' compensates the low self-esteem of white women who do not measure up to the ideal standard of beauty with the racist conviction that they are 'better' by the mere fact of being white. Women of colour in turn are stereotyped as 'dirty, ugly, stupid, lazy, uppity, devious, and promiscuous' in colonialist racist discourses. Such colonialist-racist stereotypes of femininity also serve in courts for labelling white women victims of violence such as rape or wife-beating.[29]

On the other hand, by stressing bodily symbols of women's subordination, such patriarchal feminine inscriptions aim to produce a distinct cultural, national and religious identity in 'feminine' terms that invites men to protect the 'feminine body of the people'. Hence nations, cities and churches are construed as 'feminine'. Whether it is the Pope who seeks to uphold traditional Roman Catholic hierarchy by reasserting the religious garb, veil, and cloister of nuns as distinct symbols of Roman Catholic

identity, or the Ayatollah who seeks to bolster Iranian national identity by imposing *hejab* (the Islamic veil) as basic to Islamic religious identity, both seek to maintain kyriarchal identity and power by disciplining women's bodies and controlling their lives. In the context of anticolonialist struggles, such patriarchal feminine identity-inscriptions become a site of conflicting identity discourses. In her book *Possessing the Secret of Joy*, Alice Walker sets out to explore female circumcision as a disciplining practice of such cultural-national identity struggles.[30]

This four-pronged strategy of bodily discipline is not 'forced' upon women. Rather, it is perceived to be 'freely chosen' for the sake of beauty and love. Yet, the overt aim of beauty and love is far removed and indeed contrary to the covert aim of such disciplining practices which seek to produce the feminine body as a 'subjected' docile body, on which an inferior status has been inscribed. In order to achieve bodily beauty, the love of a man and their own happiness, women must make themselves objects and prey for the consumption of men. To question these practices of 'femininity' threatens women not only with loss of skills but also with loss of self-identity and disciplining power over other women. This heterosexist regime is not only sanctioned by loss of patriarchal 'patronage' and maintained through self-surveillance and women's collusion in the disciplining of other women, but also maintained in and through the construction of religious meaning.

The religious politics of meaning

Feminist theological work on violence against women and child abuse[31] has pointed to four key traditional theological discourses that are major roadblocks in the way of abused women and children who seek to change their violent situations. *First*, the Western socio-cultural politics of subordination has its roots in Greek philosophy and Roman law and is mediated through Jewish, Islamic and Christian Scriptures. Especially, the so-called household code texts trajectory inscribed in the Christian Testament has mediated these kyriarchal discourses of subordination that demand submission and obedience not only from freeborn women, wives and children, but also from servants, slaves and barbarians – both women and men. This scriptural inscription of the patriarchal politics of subordination is compounded if it is used to provide the interpretative framework for reading originally anti-patriarchal texts that prohibit divorce as upholding patriarchal marriage relationships. It also has

disastrous effects when it provides the contextual framework of meaning for the Christian language about God and God's relation to the world. A Christian symbolic universe that proclaims an Almighty Father God whose will and command is revealed in the patriarchal texts of Scripture and doctrine legitimates and re-inscribes religiously not only misogyny, but also racism, status inferiority, homophobia and xenophobia.[32]

Not only do scriptural inscriptions reproduce this patri-kyriarchal politics of meaning but theological teachings on headship maintain patriarchal family relations and church structures. For instance, at an international symposium on celibacy in May 1993, Archbishop Francis Stafford of Denver insisted: 'The priest's personal authority is exhausted in his exercise of his authority of the head; no authority remains in him to be the head of any other "holy society" than the church. Thus for as long as he holds his priestly office and exercises Christ's headship he cannot marry . . .'[33] This christological doctrine of male headship and patriarchal authority both legitimates the exclusion of women from ordained ministries and makes it impossible for Christian children and women to resist sexual abuse by marital and ecclesial 'heads of household', by natural and spiritual 'fathers'. How can battered women or abused children turn to and trust 'priestly authority' for help, if it is the same kind of authority that maims and kills them daily?

Second, Paul's second letter to Corinth already refers to the image of marriage between Christ and the church and associates it with the deception of Eve (II Cor. 11.2–3). The pseudo-Pauline Pastoral Epistles explicitly link the kyriarchal theology of submission with the teaching on woman's sinfulness. They prescribe the silence of women and prohibit women's authority over men by claiming that not Adam but the woman was deceived and became a transgressor (I Tim. 2.11–15). Hence, the cultural pattern of making the victims of rape, incest or battering feel guilty and responsible for their victimization has its religious roots in the scriptural teaching that sin came into the world through Eve and that women's salvation comes primarily through bearing children when she continuous in 'faith and love and holiness with modesty'. This misogynist reinscription of the politics of 'femininity' and submission has been amplified by theologians throughout the centuries. Such theological discourses of victimization have either stressed women's sinfulness and culpability or their failure to measure up to the feminine ideal of 'faith, love, and holiness with modesty'. In either case, the victimized and not the victimizers are held responsible.

Third, not only traditional theological discourses but also Christian scriptural texts theologize and christologize kyriarchal suffering and victimization. For instance, the Epistle to the Hebrews admonishes Christians to resist sin to the point of shedding their blood. It points to the example of Jesus 'who for the joy that was set before him endured the cross, despising the shame'. Because they are 'sons' they have to expect suffering as disciplining chastisements from God. Just as they respect their earthly fathers for having punished them at their pleasure, so they should subject themselves to 'the Father of spirits and life' who 'disciplines us for our good, that we may share his holiness' (Heb. 12.1–11). The First Epistle of Peter, which also stands in the Pauline tradition, explicitly enjoins slaves to practise the kyriarchal politics of submission by pointing to the example of Christ. Servants are admonished to subordinate themselves not only to kind and gentle but also to unjust and overbearing masters. There is no credit in enduring beatings patiently if one has done wrong. But if one does right and suffers unjustly, one finds God's approval. 'For to this you have been called, because Christ also suffered for you, leaving you an example, that you should follow in his steps . . . for he trusted him who judges justly' (I Peter 2.18–23).

Such admonitions are not isolated aberrations, but go to the heart of Christian faith: trust in God, the Father, and belief in redemption through the suffering and death of Christ. Feminist theology has underscored the perniciousness of such theological and christological discourses which stress that God sacrificed his son for our sins. If one extols the silent and freely chosen suffering of Christ who was 'obedient to death' (Phil. 2.8) as an example to be imitated by all those victimized by patriarchal oppression, especially by those suffering from domestic and sexual abuse, one does not just legitimate but enable violence against women and children. Especially the work of Rita Nakashima Brock has shown that christological discourses which are articulated within the paradigm of kyriarchal submission 'reflect views of divine power that sanction child abuse on a cosmic scale'.[34]

Moreover, Christine Gudorf[35] has pointed out that contrary to René Girard's[36] thesis, the sacrifice of surrogate victims does not contain and interrupt the cycle of violence. Rather, by rechannelling violence, it serves to protect those in power from the violent protest of those whom they oppress. By ritualizing the suffering and death of Jesus and by calling the powerless in society and church to imitate his perfect obedience and self-sacrifice, Christian ministry and theology do not interrupt but continue to

foster the circle of violence engendered by kyriarchal social and ecclesial structures as well as by cultural and political discourses. A theology that is silent about the socio-political causes of Jesus' execution and stylizes him as the paradigmatic sacrificial victim whose death was either willed by God or was necessary to propitiate God, continues the kyriarchal cycle of violence and victimization rather than empowers believers for resisting and transforming it.

Fourth, when preached to women and subordinated men, central Christian values such as love and forgiveness help to sustain relations of domination and to accept domestic and sexual violence. Hence scriptural texts and Christian ethics often maintain the cycle of violence by preventing resistance to it. For instance, rape victims who believe obedience to God's will requires that they preserve their virginity and sexual purity at any cost not only endanger their lives but also suffer from loss of self-esteem. Hence, rape survivors feel not only that they are 'used goods' but also that they are responsible for their own rape. Battered wives, in turn, who believe that divorce is against God's will, cannot but remain in violent marriage relationships for 'better and for worse'.

Although their original intention might have been quite different, scriptural texts such as 'blessed are the peacemakers and those who suffer for righteousness sake'; 'but I say to you that everybody who is angry with his brother is liable to judgment', 'it is better that you lose one of your members than that your whole body goes to hell'; 'love your enemies, and pray for those who persecute you'; or 'do not resist evil' (Matt. 5–6) construct a sacred canopy that compels victims to accept their sufferings without resistance. Injunctions of Jesus, such as to forgive the one 'who sins against you not seven times but seventy times seven' (Matt. 18.21–22), or Paul's praise of love 'as patient and kind, not jealous or boastful, as not insisting on its own way, not irritable and resentful, bearing all things, believing all things, hoping for all things, enduring all things and as never ending' (I Cor. 13.4–8) make those feel guilty who do not patiently and lovingly submit to domestic violence, sexual abuse, or ecclesial control for resisting such violence and for having failed their Christian calling.

Children who are taught to trust and obey adults as the representatives of God, particularly parents and priests, are especially prone to become victimized. Because of such Christian teachings, incest victims do not have the spiritual means to resist the traumatic sexualization, stigmatization, betrayal and powerlessness that lead to damaged self-image and loss of self-esteem. If such victims are taught that it is essential for a Christian to

suffer, to forgive unconditionally, to remain sexually inexperienced and pure, to believe that their sinful nature is in need of redemption, and to be obedient to authority figures,[37] it becomes virtually impossible for them, particularly for little girls, either to remember and to speak about sexual abuse by a beloved father, priest, relative or teacher or to recover their damaged self-image and self-worth. No wonder that those women and children who take their faith seriously are convinced that resistance against violence is un-Christian and that their suffering is willed by God.

It must not be overlooked, however, that such patri-kyriarchal readings of scriptural texts and traditions which might originally have had an anti-kyriarchal aim are made possible in and through a discursive and institutional politics of meaning that seeks to sustain and reproduce patriarchal and kyriarchal relations of submission. Hence, if Christian theologies and churches should not continue their collusion in kyriarchal violence, they must help to fashion an 'ethics and politics of meaning' that can engender resistance to all forms of victimization and responsibility for changing structures and discourses that engender suffering, violence and murder.

Resistance and transformation

In so far as feminist movements around the world[38] have challenged patriarchal-kyriarchal regimes that sustain physical, sexual, cultural and religious violence against women, they have become primary targets for the political and religious Right. When the New Right in the USA, for instance, overtly advocates 'upholding traditional family values', its covert aim is to vindicate the legitimacy of chastizing and battering women and children in the home, to maintain silence about incest and child abuse, to attack parental leave, child care programmes, and reproductive rights, to abolish affirmative action programmes ensuring equity for white women and men of colour, to mandate prayer in schools, to censure public education and libraries and to teach creationism and sexual abstinence – and all this in defence of the 'Christian' family.

In short, the New Right seeks to recreate the kyriarchal Eurocentric society and world that existed before the changes brought about by the civil rights, women's liberation, and gay and lesbian rights movements. By co-opting civil rights and liberationist discourses the New Right casts itself as an oppressed and silenced minority fighting for their cultural and political rights that are believed to be threatened by left-wing 'political

correctness'.[39] Whereas Christian American-style religious fundamental-ism admonishes women to display their 'femininity' and to utilize make-up, cosmetic surgery, diets and fashion for seducing their husbands and maintaining their marriages, Islamic fundamentalism insists over and against Western decadence on the total covering of women's bodies in public in order to reserve women's bodies for their husbands. In so doing both types of religious regimes theologically reinscribe the socio-cultural kyriarchal construction of femininity and subordination in order to maintain heterosexist kyriarchal structures of subordination.

Still, not only the religious Right but also liberal churches and theologies reproduce the socio-cultural discourses of femininity and subordination. As long as Christian faith and self-identity remain intertwined with the socio-cultural regime of subordination and its politics of meaning they cannot but reinscribe physical and ideological violence against women and the weak. Theological and religious discourses reinscribe the inferior object status of women and reinforce rather than interrupt the victimization of women and children if they do not question but reproduce the socio-cultural inscriptions of 'femininity'. True, Christian theology overtly condemns oppressive forms of exploitation and victimization such as incest, abuse, femicide or rape. Nevertheless, Christian proclamation of the kyriarchal politics of submission and its attendant virtues of self-sacrifice, docility, subservience, obedience, suffering, unconditional forgiveness, male authority and unquestioning surrender to God's will covertly advocate patriarchal practices of victimization as Christian revelation and faith-tradition. Liberal and liberationist theologies will not be able to overcome their own violence-producing socio-cultural and religious discourses of subordination, economic exploitation and political objectification as long as they do not publicly condemn the institutionalized structures of heterosexist kyriarchal 'Christian' family and church that jeopardize the survival of the women who struggle at the bottom of the socio-cultural and economic-political pyramid of domination. As long as such structural change does not take place, Christian theologies will continue to collude in practices of physical and spiritual violence against women.

As long as Christian theology and pastoral practice do not publicly repent their collusion in sexual, domestic and political violence against women and children, the victims of such violence are forced to choose between remaining a victim or remaining a Christian. Feminist theologies have developed three strategies for addressing this either-or choice. The

first strategy of feminist studies in religion seeks to deepen this either-or alternative in order to empower women for leaving abusive situations rather than attempting to make them religiously meaningful. This strategy argues that women must abandon their oppressive Christian faith convictions in order to resist their victimization. However, such a strategy is not able to challenge the religious politics of political and religious right-wing fundamentalism on religious grounds. It deprives religious women not just of their communal support but also of the belief systems that give meaning to their life. It overlooks that religious systems of meaning collude in the socio-cultural practices of 'feminine discipline' but do not produce and sustain them. When confronted with this choice, victimized religious women are likely to intensify their search for meaning rather than resort to religious and cultural nihilism. Susan Hagood Lee aptly describes this predicament of a Christian woman:

> From my earliest years, I was a faithful churchgoer, enjoying the religious ambience, awed by the loving and all-powerful God that I believed watched over me. Then I married a man who, once the wedding ring was safely on my finger, began to abuse me. The crisis was both personal and religious. Where was God, when one month after our wedding, my husband [a bright doctoral student in psychology] first blackened my eyes, . . . when he punched me in the stomach when I was pregnant, . . . when he broke my nose because I wanted to see my family? And what did God expect of me, a wife, who had vowed at the altar to love and cherish my husband through good times and bad?[40]

Instead of rejecting her Christian faith in order to move out of her violent marriage relationship, she engages in a desperate search for Christian values that could govern and make meaningful the culturally sanctioned relationship of heterosexual marriage. In this struggle to sustain her marriage and family she discovers an unused copy of the Bible which was given to her as a wedding present. This discovery enables her to find a religious rationale for tolerating her sufferings.

> My course of action seemed clear. God's will, as the Bible instructed, was that I stay with my husband, forgiving him, when he hurt me, countering his evil behaviour with my love, cooperating with God's plan of salvation for him. It all fit into a meaningful programme for me and confirmed my desire to see my marriage work. . . .[41]

This narrative indicates that a high socio-cultural valuation of marriage and family is the driving force behind Hagood Lee's search for religious meaning.

Susan Brooks Thistlethwaite has argued that the first feminist strategy confronts women who take their Christian faith seriously with an impossible choice, in so far as it encourages women to abandon their religious affiliation without having the power to disrupt the cultural-political inscriptions of the 'feminine' politics of meaning. Hence this strategy often deepens the disempowerment of religious women who refuse to accept its solution. Therefore Brooks Thistlethwaite[42] advocates a *second* feminist theological strategy that can address the 'impossible' choice of either remaining a Christian or resisting abuse. This second feminist strategy underscores the alternative 'liberating' tradition inscribed in Christian scriptures and theologies. For countering the negative impact of texts such as Eph. 5.22 and traditions such as sacrificial christology, Thistlethwaite lifts up, for instance, texts such as Luke 4.18–20; Gal. 3.28 and Matt. 20.25–26 and theologoumena such as the incarnation of Christ, God's identification with human suffering or God's being on the side of the oppressed.

Survivors of sexual, domestic and political violence seem to confirm the validity of this second discursive strategy of feminist theology when they point to religious experiences and Christian traditions, texts and values that have allowed them to resist such abuse and to engage in the struggle to change it. To quote Susan Hagood Lee again, who speaks of the liberating power she felt when she experienced Christ as being on her side:

> I was crucified and finally knew where God was: God was hanging beside me, crucified also. I was not alone . . . Now this was not the God I had hoped for; I was looking for the knight-in-shining armour God who would . . . save me. But this rescuer God had been silent; this saviour God was dead. The God I found, the God in agony, the God with me in my pain, became my new God.[43]

However, it is not clear from her narrative why she does not extrapolate from this experience that because Christ suffered with her she had to continue to bear unjust suffering. Rather surprisingly she declares: 'This God did *not* want me to suffer; this God wanted me to be happy. But I had to save myself; God would not do it for me.'[44] This surprising conclusion, I submit, was not just engendered by her 'mystical' experience of God's

suffering but was made possible by an experience she had mentioned earlier:

> The only drawback for me . . . was the business about turning the other cheek . . . I never offered him my other cheek. My lived experience of violence conflicted with the Bible-based rationale I had worked out, and this conflict was the seed of my eventual escape from abuse.[45]

Hence, Susan Hagood Lee's experience points to a third possible feminist theological strategy for transforming the impossible either-or choice which religious women confront who suffer from abuse and violence. I suggest that this third feminist strategy must focus on women's religious agency and theological subjectivity and foster resistance and change by exploring the contradictions between the religious-cultural kyriarchal politics of 'femininity' on one hand and the religious-cultural emancipatory politics of meaning and self-worth in the eyes of God which is inscribed in Christian texts and traditions on the other. Whereas the first two feminist theological strategies valorize either one or the other side of the dualistic alternative (leave Christianity or remain a Christian in a situation of abuse), this third strategy seeks to shift the theological discourse on violence against women and children by focussing on the contradiction between the lived experience of survivors' agency and the discursive theological meanings that negate such agency.

Speaking from within relgiious and cultural communities, discourses and traditions of meaning, such a critical feminist theology of liberation contests the authority of the practices and discourses that advocate the politics of subordination and violence on theological grounds. By bringing out the contradiction between the overt and covert aims of cultural and religious practices of 'feminine' inscription as well as by providing contesting resources of meaning it aims to empower those victimized by kyriarchal oppressions and the whole Christian community to believe in a God who is with us in our struggles to eradicate violence and to foster self-determination, dignity and well-being for all. This issue of *Concilium* seeks to take a small step in this direction.

Notes

1. Since feminist discourses tend to understand 'patriarchy' (lit. reign of the father) primarily in terms of gender oppression, I have coined the neologism 'kyriarchy' (lit.

the reign of the lord/master) in order to underscore that Western patriarchy has been and still is kyriarchy, i.e. ruling power is in the hands of elite propertied educated freeborn men (in German *Herr-schaft*).

2. 'With no immediate cause', in Ntozake Shange, *Nappy Edges*, New York 1972.

3. Cf. J. Hanmer and M. Maynard (eds.), *Women, Violence, and Social Control*, London 1987; Kate Young, Carol Wolkowitz and Roslyn McGullagh, *Of Marriage and the Market: Women's Subordination in International Perspective*, London 1981; Roxana Carillo, *Battered Dreams. Violence Against Women as an Obstacle to Development*, New York 1992; Margaret Schuler (ed.), *Freedom from Violence. Women's Strategies from Around the World*, New York 1992; Jessie Tellis Nayak, 'Institutional Violence Against Women in Different Cultures', *In God's Image*, September 1989, 4–14.

4. Yvonne and Chandana Yayori (eds.), 'Prostitution in Asia', *In God's Image* 9, June 1990; Elizabeth Bounds, 'Sexuality and Economic Reality: A First and Third World Comparison', *In God's Image* 9, December, 1990, 12–18; Mary Ann Millhone, 'Prostitution in Bangkok and Chicago – A Theological Reflection on Women's Reality', *In God's Image* 9, December 1990, 19–26.

5. Charlotte Bunch, *Gender Violence: A Development and Human Rights Issue*, New Brunswick, NJ 1991.

6. For the discourses of Purdah see Edda Kirleis, 'Between Exclusion and Integration: Women Workers in Bangladeshi NGDOs', *Lila. Asia Pacific Women's Studies Journal*, 1, 1992, 50–65.

7. Sun Ai Park and Yvonne Dahlin (eds.), 'Militarization and Women', *In God's Image* 9, March 1990.

8. Carol Medel Añonuevo, 'Feminist Reflections on the International Migration of Women', *Lila. Asia Pacific Women's Studies Journal*, 1, 1992, 42–9; see also Mayan Villalba (ed.), 'Women in Migration', *In God's Image* 11/1, 1992.

9. Emeka Onwurah, 'The Treatment of Widows in a Traditional African Society – A Challenge to Christian Women', *In God's Image* 10/1, 1991, 36–40.

10. See Lori Heise, 'Violence Against Women, the Missing Agenda', *Women's Health: A Global View*, New York 1992.

11. *The Women's Action Coalition Stats: The Facts about Women*, New York 1992, 18f.

12. For statistics cf. *WAC Stats: The Facts About Women*.

13. Haleh Afshar, 'Women, Marriage and the State in Iran', in Haleh Afshar, *Women, State and Ideology, Studies from Africa and Asia*, Albany 1987, 70–88: 73.

14. Patricia Gossmann, 'Widespread Rape in Kashmir Escapes the Spotlight', *Human Rights Watch* 11/2, 1993, 3, and Therese Caouette, 'Burmese Girls Forced into Prostitution in Thailand', ibid., 4.

15. Jill Radford and Diana E. H. Russell, *Femicide, the Politics of Woman Killing*, New York 1992.

16. *The Women's Action Coalition Stats: The Facts about Women*, New York 1993, 56.

17. Jaquelyn C. Campbell, '"If I Can't Have You, No One Can"; power and Control in Homicide of Female Partners', in Jill Radford and Diana E. H. Russell, *Femicide the Politics of Woman Killing*, New York 1992, 99–113: 101.

18. See for instance Rowena Unas, 'Violence Against Women in the Philippines',

Lila. Asia Pacific Women's Studies Journal 1, 1992, 5–11.

19. Sarah Y. Lai, 'No Way to Treat Guests: Asian Maids in Kuwait', *Human Rights Watch* 11/2, 1993, 5.

20. 'Die Opfer des Frauenhasses', *Emma*, March/April 1993, 29.

21. *Emma*, May/June 1993, 85.

22. Robin Morgan, 'Isolated Incidents?', *Ms. Magazine* 3/5, 1993, 1.

23. For such a distinction see my books *Discipleship of Equals. A Feminist Ekklesialogy of Liberation*, New York and London 1993, and *But She Said, Feminist Practices of Interpretation*, Boston 1992.

24. See for instance Andrea Dworkin, *Woman Hating*, New York 1974; Mary Daly, *Gyn/Ecology, The Metaethics of Radical Feminism*, Boston and London 1978; Wolf Naomi, *The Beauty Myth*, New York 1991.

25. Sandra Lee Bartky, 'Foucault, Femininity, and the Modernization of Patriarchal Power', in Irene Diamond and Lee Quinbee (eds.), *Feminism and Foucault. Reflections on Resistance*, Boston 1988, 61–86.

26. Lori Stern, 'Disavowing the Self in Female Adolescents', in Carol Gilligan, Annie G. Rogers and Deborah L. Tolman (eds.), *Women, Girls and Psychotherapy. Reframing Resistance*, New York 1992, 105–18.

27. Peggy McIntosh, 'Feeling Like a Fraud', *Work in Progress. No. 18*, Wellesley, MP, Stone Center Working Paper Series, 1984, 1.

28. For these terms see Katie G. Cannon, 'Womanist Perspectival Discourse and Canon Formation', *Journal of Feminist Studies in Religion* 9, 1993, 29–38: 31f.; see also Katie Russel, Midge Wilson, Ronald Hall, *The Color Complex*, New York 1992, and Chandra Taylor Smith, 'Wonderfully Made: Preaching Physical Self-Affirmation', in Annie Lally Milhaven (ed.), *Sermons Seldom Heard. Women Proclaim Their Lives*, New York 1991, 243–51.

29. Cf. Martha Mamozai, *Herren-Menschen. Frauen im deutschen Kolonialismus*, Reinbeck 1982, 160; May Opitz, Katharina Oguntoye and Dagmar Schultz (eds.), *Showing Our Colors. Afro-German Women Speak Out*, Amherst: Mass. 1992.

30. Alice Walker, *Possessing the Secret of Joy*, New York 1993. See also the exploration of this controverted issue by the Kenyan writer Ngugi wa Thiongo, *The River Between*, Oxford 1965.

31. See for instance Regula Strobel, 'Der Beihilfe beschuldigt. Christliche Theologie auf der Anklagebank', *Fama. Feministisch Theologische Zeitschrift* 9, 1993, 3–6, for a review of the discussion.

32. For historical documentation and theo-ethical evaluation of the politics and theology of submission see my books *Bread Not Stone: The Challenge of Feminist Biblical Interpretation*, Boston 1984, 65–92, and *In Memory of Her: A Feminist Historical Reconstruction of Christian Origins*, New York and London 1983, 243–314.

33. As quoted by A. W. Richard Sipe, 'Celibacy and Imagery: "Horror Story" in the Making', *National Catholic Reporter*, 2 July 1993, 5.

34. Rita Nakashima Brock, 'And a Little Child Will Lead Us: Christology and Child Abuse', in Joanne Carlson Brown and Carol R. Bohn (eds.), *Christianity, Patriarchy, and Abuse: A Feminist Critique*, New York 1989, 42–61: 43. See also her book *Journeys by Heart: A Christology of Erotic Power*, New York 1988.

35. Christine E. Gudorf, *Victimization. Examining Christian Complicity*, 1992, 14–15.

36. Cf. René Girard, *Job: Victim of His People*, Stanford 1977 and *Violence and the Sacred*, Stanford: 1977.

37. Sheila Redmond, 'Christian "Virtues" and Recovery from Child Sexual Abuse', in Joanne Carlson Brown and Carole R. Bohn (eds.), *Christianity, Patriarchy, and Abuse: A Feminist Critique*, New York 1989, 70–88: 73f.

38. For documentation see Robin Morgan (ed.), *Sisterhood is Global. The International Women's Movement Anthology*, Garden City, NY 1984.

39. Cf. the analysis of Heather Rhoads, '"Racist, Sexist, Anti-Gay . . ." How the Religious Right Helped Defeat Iowa's ERA', *On the Issues*, Fall 1993, 38–42.

40. Susan Hagood Lee, 'Witness to Christ, Witness to Pain: One Woman's Journey through Wife Battering', in Annie Lally Milhaven (ed.), *Sermons Seldom Heard. Women Proclaim Their Lives*, New York 1991, 11–22: 11.

41. Ibid., 13.

42. Susan Brooks Thistlethwaite, 'Religious Faith: Help or Hindrance', *In God's Image* 9, December 1990, 7–11.

43. Ibid., 15.

44. Ibid.

45. Ibid., 13.

I · Violence against Women: Exploring Sociocultural Analysis and Gender Construction

Because of the Angels: Sexual Violence and Abuse

Joanne Carlson Brown

I commend you because you remember me in everything and maintain the traditions just as I handed them on to you. But I want you to understand that Christ is the head of every man, and the husband is the head of his wife, and God is the head of Christ. Any man who prays or prophesies with something on his head disgraces his head, but any woman who prays or prophesies with her head unveiled disgraces her head – it is one and the same thing as having her head shaved. For if a woman will not veil herself, then she should cut off her hair; but if it is disgraceful for a woman to have her hair cut off or to be shaved, she should wear a veil. For a man ought not to have his head veiled, since he is the image and reflection of God; but woman is the reflection of man. Indeed, man was not made from woman, but woman from man. Neither was man created for the sake of woman, but woman for the sake of man. For this reason a woman ought to have a symbol of authority on her head, because of the angels (I Corinthians 11. 2–10).

The acts of sexual violence in the Bible are too numerous to count. Why select this text with which to begin this article? Why not the rape of Tamar or the unnamed concubine or Dinah? What does the debate over head covering have to do with sexual violence and abuse? Everything. In this passage we find the justification for men's position and authority over women not just based on theology (Christ is the head), but also on sex and power. Paul asserts in this passage of instruction to the church at Corinth that men are women's lords and masters, that women were created for men and that they are his image and reflection, not God's. That explains the

power, but what of the sex? Paul exhorts women to veil their heads and not to cut their hair – Why? Because of the angels. Paul is here referring to Genesis 6 where the sons of God are tempted by the beauty of the daughters of men and 'they took wives for themselves of all that they chose'. God was displeased by this – so displeased that the story of the flood immediately follows this passage. This is just one of a number of biblical stories where women are blamed for evil, but Paul's use of this Genesis passage and the subsequent mythology which has entered our culture make this one of the most damning of texts in relation to violence against women. Women must cover themselves because they can tempt even the angels to fall. But this 'sexual power' can be kept under control by the God-given authority of his images to own, subdue, use and punish these paltry reflections of their lord and master. This is the natural order. Because of the angels.

It is crucial that we see this issue of sexual violence and abuse in its true context – an abusive society maintained and supported by the dominant mythologies of the day, foremost among them being Christianity with its sacralizing of a patriarchal, hierarchical system of domination and submission, ; with its mixed messages of servanthood and forgiveness; and with its glorification of suffering through its teaching and theology, its liturgies and its rituals.

We have been conditioned to see violence as episodic, an anomaly in a basically civilized culture. The reality is, as Mary Hunt pointed out in a recent lecture,that violence is contextual and justice is episodic. If this is the case with all violence, it is especially so with sexual violence. Sexual violence is epidemic, not occasional, more normal than marginal. Violence against women and children is not restricted to the isolated actions of insane men at unpredictable moments. Abusers are not just monsters and drunkards or stalking strangers. They are ordinary men living apparently ordinary lives. They and their victims belong to no one class, religion, race, group or nationality. Sexual violence is commonplace.

This is played out by the disturbing statistics which parade across our desks every day. The Center for the Prevention of Sexual and Domestic Violence (located in Seattle, Washington, USA) estimates that one girl out of three and one boy out of seven are sexually abused by the age of eighteen. According to US Health and Human Services, in almost 98% of the known cases, the child is abused in the home by a close relative, a family friend, or a neighbour. Fathers are the single largest group of abusers (77%). In Dianne Russell's study of rape, 44% of the women interviewed had been

subjected to rape or attempted rape, and contrary to prevalent stereotypes strangers accounted for only 11% of the perpetrators. Her work also indicated that the rape rates are rising; in every age-group the rape rates are significantly higher than for the same age-group in any earlier period. These statistics could go on and on. And what is more sobering is that everyone who deals with sexual violence and abuse agrees that there is vast under-reporting. Reliable statistics are difficult to establish. Whatever the numbers or percentages, what is clear is that we live surrounded by the reality and the fear of violence, sexual violence.

But we have become immune to statistics, I fear. One daughter's experience of incest is a tragedy. Ten girls are horrible. A thousand is a statistic. The pervasiveness of sexual violence has allowed us to become callous and accepting. The most perplexing dimension of violence against women for me is how it is taken for granted. When you read or hear the stories of sexual violence, they are stories of terror and torture. But this violence and abuse has been glamourized for us in movies, 'romance' novels, advertising, and more insidiously in our sacred stories.

Part of the problem is in the definition of violence. The most common would be bodily harm to another person. But that soon gets complicated. What one person may perceive as harm another does not. And there are the kinds of violence, usually delineated as individual (such as rape, homicide and battering) and systemic (corporate, nationalism, capitalism, sexism, racism, homophobia). Clinical research shows that individual violence is a reaction to or a defence against feelings of helplessness. Factors such as low self-esteem, lack of impulse control, failure to learn skills to achieve goals by non-violent means, poverty, unemployment, overcrowding and substance abuse can play a part. But the key psychological dynamic of violent behaviour is an unbearable experience of helplessness. Thus individual and systemic violence are closely linked and almost inseparable. This is even clearer when dealing with sexual violence in particular. Man's sense of masculinity is based on feelings of power and control. When that is lost or when that cannot or does not exist for whatever systemic reason, then violence is the result, and it is women and children who bear the disproportionate brunt of this violence.

But not everyone agrees that sexual violence is violence. This is particularly true of rape. A male juror in a trial dealing with a woman (Inez Garcia) who had murdered her rapist made the following statement to a reporter: Could a woman ever successfully plead self-defence if she killed a man during a rape attack? 'No, because the guy's not trying to kill her. He's

just trying to give her a good time. [For her] to get off, the guy will have to do her bodily harm, and giving a girl a good screw isn't doing her bodily harm.' Sexual violence is not about sexual need, not about sexual interest or sexual pleasure. It is about power and control and anger. These are acted out in a sexually violent manner. These are sexual assaults. The victims are not 'just' hit; penises, even Coke bottles and broomsticks are used to assault women's sexuality. Sexual violence and abuse need to be seen in this misogynistic context. This is not just an attack, it is an attack against a woman, against her very being, against the 'powerful and uncontrollable' aspect of her very self. Sexual assaults are the ways the patriarchy has to keep women and children in their place.

Even if one has not directly experienced sexual violence and abuse, the sheer scale and extent of the abuse creates a climate of vulnerability and fear which shapes all our daily experiences and relationships. It is intended if it is to be an effective means of control. Robin Morgan in her book *The Demon Lover* demonstrates this very well.

> Look closely at her.
>
> She crosses a city street, juggling her briefcase and her sack of groceries. Or she walks down a dirt road, balancing a basket on her head. Or she hurries toward her locked car, pulling a small child along with her. Or she trudges home from the fields, the baby strapped to her back.
>
> Suddenly there are footsteps behind her. Heavy, rapid. A man's footsteps. She knows this immediately, just as she knows that she must not look around. She quickens her pace in time to the quickening of her pulse. She is afraid. He could be a rapist. He could be a soldier, a harasser, a robber, a killer. He could be none of these. He could be a man in a hurry. He could be a man merely walking at his normal pace. But she fears him. She fears him because he is a man. She has reason to fear.
>
> She does not feel the same way – on a city street or dirt road, in parking lot or field – if she hears a woman's footsteps behind her.
>
> It is the footsteps of a man she fears. This moment she shares with every human being who is female.
>
> This is the democratization of fear.

There are many kind of sexual violence and abuse. However, we can place them in a few generalized categories. The first issue of violence against women which began to be seriously addressed by feminists is rape.

There are many myths associated with this act. Women want it – when rape is inevitable, lie back and enjoy it. Women ask for it by the way they are dressed, the way they walk. This reached an absurd height when a judge stated that a two year old had sexually come on to a man who was on trial for sexually assaulting her. Rape victims are also blamed for their rape – if they had only fought harder . . . What were you doing out at night anyway? Rape is an act of violence that is often trivialized, joked about, and dismissed. It is a powerful tool of the patriarchy and is wielded against women, children and some men to humiliate, dominate and control. Susan Brownmiller in her ground-breaking book, *Against Our Will*, has categorically stated that all men are rapists. This is true in the sense that women experience all men as potential rapists and speaks to the power of this patriarchal weapon.

She also discusses an aspect of rape that has received increasing coverage – rape in war. It has been argued that, when killing is viewed as not only permissible but heroic behaviour sanctioned by one's government or cause, the fine distinction between taking a human life and other forms of impermissible violence gets lost, and rape becomes an unfortunate but inevitable by-product of the necessary game called war. But rape is more than a symptom of war or evidence of its violent excess. Rape is a form of control, of showing superiority to those defeated. But more devastating as Brownmiller points out, 'War provides men with the perfect psychological backdrop to give vent to their contempt for women.' One Vietnam veteran remarked, 'They were *forcibly willing* (italics mine) – they'd rather do that than get shot.' The resistance to placing rape in war in the category of war crimes demonstrates that this attitude is shared by political leaders as well.

Another aspect of rape which is getting a great deal of attention of late is date or acquaintance rape. Violence against young women in heterosexual dating relationships is played out in what Janice Raymond calls hetero-reality, that is, the world view in which woman exists for man. Within the context of hetero-reality, adolescent dating relationships are characterized by domination of young men over young women: they demand a young woman's dependence, and they necessitate her servitude to and identification with young men. They are relationships in which young men establish the rules in their interests and young women accommodate. These young women are guilted, blackmailed and physically forced into sex. More insidious is the fact that in this 'culture' the women blame themselves perhaps more and will deny that anything has happened longer than in other kinds of rape.

Incest and child sexual abuse is a special kind of rape. It is a crime that may continue for years, and its victims are trapped not only by brute force but by loyalties and dependencies. The stories are heart-wrenching and terrible. Elly Danica's *Don't: A Woman's Word* is perhaps the most revealing and perceptive of the public stories thus far. The jokes surrounding this issue (if you can't keep it in the pants, keep it in the family) speak volumes about the attitude prevalent in this patriarchal culture. It is an attitude supported by the sacred literature and religious mythology which has developed from it. The Bible portrays Lot's daughters as the instigators of incest (for an approved purpose – the preservation of the line). This after their father has offered them as a substitute to protect the male strangers from sodomy. Incest and rape are not included in the Ten Commandments and there is significant discussion among scholars whether the prescriptions in Leviticus are really dealing with incest or just multiple, possibly competitive sexual partners. And perpetrators will often use religious reasons for their actions: the Bible says 'Do not commit adultery', so I couldn't go to a prostitute. Children are viewed as possessions. Children are taught to honour their father and their mother. Children are not believed when they disclose sexual abuse. It is chalked up to fantasy. But whose is the real fantasy?

The use of sexual violence and abuse in the culture for entertainment and commercialism is well documented and widespread. The bridge between this use of women's and children's bodies in popular culture and the use of women's and children's bodies by rapists and sadists is a short one and easily crossed: the way is paved with pornography. Pornography is only secondarily concerned with sex; its main function is to be a vehicle for male power. A full discussion of this issue is beyond the scope of this essay, but the link must be mentioned.

Another issue surrounding sexual violence and abuse is men as victims. I do not want to deny the reality of this, but this too fits in the patriarchal construct. These men are generally being disciplined for stepping out of the pattern. They are being relegated to being treated as women in a misogynist society that regards this as the greatest insult you could say to a man. Witness the school-ground insults shouted at boys: pussy, cunt, sissy and the most damning: 'You woman'. Sexual, derogatory, violent.

All violence, especially sexual violence, is destructive – physically and spiritually. It threatens self-respect and trust and gives rise to feelings of powerlessness, helplessness, humiliation, worthlessness and self-blame. Violence against women and children silences them by paralysing their

minds and emotions, taking away the ability to act and their ability to vision an alternative future. There is a great deal of healing that must take place. This is not only within the individual, but must also result in a transformed society. What is the role of Christianity and the church in this process?

Violence against women is more possible in situations where the church's teaching and practice legitimize the inferior status of women over against men. This has been the legacy of the church. This legacy is echoed over and over again at conferences, in counselling offices, in seminaries, as a depressing litany of Christian complicity in male violence and failure to bring healing and hope into the lives of survivors is heard: clergy who disbelieve or blame; clergy for whom the sanctity of marriage and family is more valuable than the sanctity of life sending women and children back into abusive situations with exhortations of obedience; women who were simply too scared to share their problems within the church for fear of judgment and rejection; women and children, already overwhelmed by feelings of shame and guilt, who come to believe that the church and therefore God is on the side of suffering and violence; survivors and current victims who question: 'What did I do to deserve this? I must be bad and wicked for God to punish me so.' These women either remain in the church – torn, broken, disorientated and self-hating – or they reject the God and the religion which seem to be obstacles to the struggle to heal and reclaim their identity and integrity. Is this the way it has to be?

Christianity has overwhelmingly accepted and affirmed male control, and has been equivocal, to say the least, in challenging prevailing assumptions about masculinity. Historically, women have been marginalized and devalued by the language, the teaching and the organization of the church. They have been objects of contempt, veneration, patronization and exploitation. Until the church reconsiders the extent to which Christian theology, biblical interpretation and church structures are linked to male aggression and violence it will be a hindrance, not a help. Again, it is outside the scope of this article to develop this position fully. A few observations will serve as examples.

The basic Christian beliefs and principles regarding sin and guilt, sexuality, authority issues, suffering and forgiveness create blocks to successful healing. We must also address the image of God. If God is presented as all powerful, judgmental, capricious, requiring passive obedience, and male, we have just described the experience of women and children who have had their autonomy and personhood destroyed by men.

We must examine the role of the atonement in supporting the abusive culture. The image of 'divine child abuse' is the central image around which all theology, worship and ritual are developed. Sheila Redmond in her recently completed dissertation on God and father-daugher incest has observed that the stories we tell in church, especially around the passion of Jesus, are imbued with violence. Supposedly they are the stories about a loving God and how he cares for his children. What they are, are stories about a God who does not accept disobedience, requires that his children suffer, and punishes them when they fail. Furthermore, he is not above sacrificing one of them when he thinks it is necessary, whether it is his own son or an eleven-year-old girl.

Sexual violence and abuse are realities. They are the major tools of the patriarchy to shore up the domination of men over women. Christianity is a supportive presence in this power play. To ignore or deny this would be to place women and children at even more risk. We must meet these demons of the principalities and powers. Because of the angels.

Recommended Reading

Kathleen Barry, *Female Sexual Slavery*, New York 1984

Claudia Camp and Carole R. Fontaine (eds.), *Women, War, and Metaphor: Language and Society in the Study of the Hebrew Bible*, Atlanta 1993

J. Carlson Brown and R. Parker (eds.), *Christianity, Patriarchy, and Abuse: A Feminist Critique*, New York 1989

Del Martin, *Battered Wives*, New York 1976

Marie M. Fortune, *Sexual Violence. The Unmentionable Sin*, New York, 1983

R. Gelles and C. Pedrick Cornell (eds), *International Perspectives on Family Violence*, Lexington 1983

Ilse Müllner, 'Bibliographie: Gewalt gegen Frauen', *Schlangenbrut* 11, 1993, 36–7

Rita Nakashima Brock, *Journeys by Heart: A Christology of Erotic Power*, New York 1988

Mary Pellauer, 'Moral Callousness and Moral Sensitivity: Violence Against Women', in B. H. Adolson, C. E. Gudorf and M. D. Pellauer (eds.), *Women's Consciousness, Women's Conscience*, Oak Grove 1985, 33–50

Florence Rush, *The Best Kept Secret: Sexual Abuse of Children*, Chicago 1983

Schechter, Susan, *Women and Male Violence: The Struggles of the Battered Women's Movement*, Boston 1982

'Sexuelle Ausbeutung', *Fama* 9/2, 1993

Susan Brooks Thistlethwaite, *Sex, Race, and God: Christian Feminism in Black and White*, New York 1989

Prostitution and Rape in the Colonial Period

Zilda Fernandes Ribeiro

Introduction

Throughout human history women have had to bear the burden of their feminine nature or, better, of their sex. The history of colonial Brazil is no exception to this rule. Women in Brazil were objects of the unrestrained desires of their male partners, whether they were Indians, blacks, mixed race or white, and whatever the stage of the colonial process, the rubber boom, the gold rush, the coffee economy, and so on. It is the same today at the end of the twentieth century in the gold-diggings, that is, the colonialism that continues into our own time.

The evidence from today shows that there has been little improvement in this particular respect.

Brazil maintains its dismal position as the record-holder in violence, with 300 complaints a day to police stations about violence against women. The Brazilian Chamber of Deputies parliamentary commission of enquiry into violence found that in the period January 1991–August 1992 alone more than 200,000 complaints of this type were recorded in police stations specializing in women's issues. Of this total more than 50% concerned violent sexual assaults, kidnapping, unlawful imprisonment, and racial and professional discrimination.

Brazil also holds another dismal record, that of being the leader in child prostitution in Latin America, and in second place in the world, according to the Ministry of Social Welfare, with 500,000 cases. In first place is Thailand, according to the United Nations Research and Training Institute for the Advancement of Women, with 800,000 girl prostitutes. Thai girls are exported to other Asian countries.

Brazil is on the 'porno-tourism' route, and popular with Europeans, especially Italians and Germans, according to reports by feminist movements. These reports were presented at the World Human Rights Conference in Vienna at the beginning of June 1993. Shock headlines spread the gloomy news throughout the world. Every year two million girls are sexually mutilated; they are among the 85 million to 114 million women throughout the world who undergo partial or total clitoridectomy and infibulation of the vagina. According to the World Health Organization, this practice is damaging to health, apart from being a violation of human rights. Nevertheless it is a widespread practice in many countries.

The prostitution and enslavement of girls in Brazil is world news. Amazonia is the worst region, with its centres of prostitution: girl slaves are bought from their families and taken by force to the brothels and then prevented from leaving.

Against the background of these disturbing reports about a phenomenon that brings shame on humanity as a whole, when we might have expected a new century to bring a better world, without rape and prostitution, the first part of this article will merely note the presence of rape and prostitution in almost all cultures.

The second part will look at some Latin American countries during the colonial period,[1] and then Brazil during the colonial period and today.[2]

I Prostitution and rape in almost all cultures

Woman of adventures,
 my sister.
Of all times.
Of all races.
Of all latitudes.
She comes from the immemorial depths of the ages
and carries the heavy load
of the vilest synonyms,
labels and epithets:
scarlet woman,
street woman,
fallen woman,
no-good woman.
Woman of adventures,
 my sister.

Downtrodden, scorned and threatened,
unprotected and exploited,
ignored by the law, by justice and right.

These fragments of a poem by Cora Coralina, a writer and feminist from Goiás, challenge us at the beginning of this reflection on a phenomenon that is complex and extensive, present in almost all cultures and all periods. 'Your life is biology,' is a saying familiar in all social strata and one adopted by Western macho ideology and so exploited 'in all ages, in all races and in all latitudes'.

Since prostitution and rape are so difficult to address and seem to disappear in the mists of time, while at the same time being part of the everyday facts of history, as omnipresent as the air we breathe, though thoroughly foul, especially for women, it seems impossible to imagine a society without prostitution and rape. It is a complex and multifaceted phenomenon among human beings, as can be seen even from the terms used to define this type of violation and exploitation of women in their most intimate sphere.

Dictionaries give an example of the variety of uses of a term whose core meaning is an insult and attack on the human lives of countless women all over the world, of all races and ages, which leads to the ruin of their lives, if not to death. Under 'rape' the *Concise Oxford Dictionary* has the following entry:

> 1. (Poet.) Take by force. 2. Commit rape on (woman). 3. (Poet.) Carrying off, esp. of woman, by force. 4. Forcible or fraudulent sexual intercourse imposed on women (statutory rape: sexual intercourse with girl below the age of consent); (fig.) forcible interference with institution, country, etc.; violation of (From Lat.: *rapere – raptar*).[3]

No one can deny that rape is abominable. Can legal language take for granted the meaning of rape, or is change in laws on rape a vital form of action against rape? These are some questions being asked, though the answers are not encouraging, even though laws relating to sexual offences have been or are being constantly examined throughout the Western world.

In the context of the 'nature-nurture' debate, rape is presented, according to viewpoint, as a crime, a vice, a ritual, physical violence or a perversion, or simply as another word for sex, something like 'seduction' or 'possession'.

Rape can be studied in anthropology, philosophy, law, psychoanalysis, history or religion. From the standpoint of criminal justice, seen from the standpoint of the victim, it leads to accusations, verdicts, convictions or acquittals.

It can be seen as a matter for political philosophy, in philosophical theory, if the problem is seen as a social evil, or if considered a philosophical issue it becomes a problem in applied ethics or in value theory.

It can be analysed from the view point of psychoanalysis. In the 1890s Freud put forward an aetiology of neuroses, in which he described it as seduction instead of rape. It can be seen as a way of silencing women, or it can be studied in merely biological terms. Finally, it can be studied in the visual arts, connected with the mythology of different cultures, and studied as culture in popular art, etc.

Rape cannot be treated as an isolated incident, simply one man – a 'sex maniac' – sexually attacking one woman. There are articles and books that contain outrage and anger at rape, but no analysis that takes account of what was wrong with men and a men's world to produce such a volume of abominations against women.

Many questions remain unanswered, and in many areas basic information is lacking. How is one to ascertain rape, for example, in countries where machismo is rampant, and women are at the end of the twentieth century still objects of misogynist laws which legitimate atrocities such as forced marriages, sexual mutilation, physical and spiritual violence, incarceration and even execution?[4]

Is rape today a more serious or less serious problem than 500 years ago, and what can scientists tell us about the reasons for rape and prostitution? Can we know what happened to the women of Latin America in the colonial period?

Since there is no history of rape, especially one focused on Latin America in the colonial period, and because of other assumptions about rape, we need to be very cautious in projecting current concerns into the past.

In a world in which women are treated mainly as means rather than ends, as objects rather than subjects, the relative silence of men in modern times about rape may point us in the right direction. With this presumption and our suspicions, and silences and unanswered questions, we have the right to make use of the meagre historical fragments that have come down to us.

II Prostitution and rape in Latin America

We know that historical memory is one of the key instruments in reconstructing the identity of a people and stimulating its resistance, but women have no historical memory of this sort because 'the thinking of the Enlightenment was still dominated by the concept of a universal subject, which amounted to excluding women from history'.[5]

Today our solution is deconstruction, to dismantle universal totalities and reconstruct the narrative from the sidelines of the official version.

A monumental work was recently published in Brazil on the 'spiritual conquest of Spanish America', which made available 200 sixteenth-century documents, but it brought no answers to our questions. Our problem is silence and invisibility, the result of an attempt to eliminate what was always determining in life, difference in gender. It is impossible to eliminate the relations that produce life, even though in the history of Latin America the balance is in favour of death rather than life.[6]

Furthermore, it is impossible to extinguish the memory of the everyday events of history. 'In this case the "ordination" of everyday life is a far from everyday phenomenon: the representative, "provocative", exceptional character transforms the ordination of everyday life into political moral activity.'[7]

In this way the women of Latin America, in this particular aspect, are weaving their own history. Enrique Dussel is firm: Amerindian women are the mothers of Latin America, and were oppressed in a very specific way: they suffered the violence of the dominant power of the European conquerors.

In his book, *The Conquest of America – The Problem of the Other*, Tzvelm Todorov stresses that Columbus discovered America, but not the Americans. The contempt for these others as persons, as living agents in history, was general, and in relation to indigenous women it was even more terribly sad because 'Indian women were classified on the same level as animals'.[8]

There is a striking convergence in research into sexual oppression throughout Brazil and in other countries of Latin America, on issues such as violation, physical appropriation and sexual abuse. After the Indians it was the turn of black women, followed by those of mixed race.

In Peru the European invasion brought about a confluence of two patriarchal currents:

The Incas, like many other societies, established a system of exchange of women. The exchange of women between victors and vanquished produced a system of power alliances. This implied male polygamy and female monogamy, in addition to control over the sexuality of a large group of women.[9]

The Spanish fitted very well into this structure of Inca society, since it gave them another weapon with which to dominate the indigenous even more, and they exploited it when they broke the Inca siege of Lima. Their leaders might have several concubines, as in the case of Francisco Pizarro, who traded in women with Atahualpa.

It remains to be discovered what it meant for these women to be treated as commodities by the leaders of their own tribes, becoming the sexual objects of unknown men. The work of reconstruction being undertaken by Latin American women, piecing together oral history and popular traditions, is beginning to reveal a different picture of Latin American women from the stereotype of the servile, passive, submissive woman found in colonial literature. In 1760 in Peru, the brave chief Tupac Amaru was accompanied by Micaela Bastides and her group of women warriors, who were the heart and soul of his rearguard: 'She was led to the scaffold on 18 May 1781 like so many othes. Micaela has been declared the mother of the Peruvian people.'[10]

We now know at least of reports from reliable sources that the women rebelled against the colonial rules and refused to sleep with the Spanish or with their own husbands in order not to produce slaves, in order not to perpetuate the system of slavery.

III Prostitution in colonial Brazil and Brazil today

The oldest area of European occupation in Brazil is the Amazon Delta. Portuguese soldiers and colonists established themselves here in the first years of the seventeenth century, initially to drive out the French, English and Dutch who were disputing control of the area.[11]

> This pattern of occupation involved violence of every kind: For this enterprise of destroying the rain forest, and exploiting its products, the Indians were recruited from the very beginning, by means of all kinds of compulsion, from 'subjugation' and resettlement in missions and colonial posts to devious methods, such as accustoming them to the use of traded commodities, which were subsequently provided only on

condition that they took part in production as labour for all kinds of tasks.[12]

The reason for this wave of violence was the increasing demand for the coagulated latex of certain plants known to the Indians from time immemorial and used by European industry.[13] And 'one of the common practices for bringing the Indians under control was to kidnap the women and children within their own village under the supervision of the overseer'.[14] For the Indians the situation was desperate: for them it represented death by the denial of everything they needed to live: the occupation of their land, the break-up of their families, with the men dispersed and the women seized.[15]

Araújo Lima (1945: 266), in his study of Amazonia, shows how the 'lack of women dictated, at the height of the rubber boom, a veritable traffic in fallen women. They were enticed by the traders of Belém and Manaus, and despatched to the rubber plantations with an invoice for price and transport costs like any other commodity.'[16]

What happened in that period can be imagined from what happens today in the same region. Today young girls descended from the same indigenous women of the same region are heirs to the same misfortunes of Amazonia. They are girls of eleven to fifteen, thrown on to the streets by poverty since the age of eight, for the same reasons as in the colonial period, the same enslavement and poverty.

In the Belém region, on the trade route young virgins are even auctioned. There are establishments specializing in dealing in hymens, known in the region as 'stamps'. 'The girls are made drunk and then handed over to the men.'[17] Just as their ancestors were 'invoiced and despatched' for the use of their purchasers, to satisfy their appetites, these girls today are worn out at eighteen, riddled with disease. In the gold-prospecting regions around Belém the prospectors call a woman of over eighteen a 'hen', and one under eighteen a 'chicken'.

On the traffic route there is a remark current among men partial to 'chickens': 'Anything over fifteen kilos will do.' This is the testimony of the psychologist Maria Luisa Pinheiro of the Brazilian Centre for Childhood and Adolescence.[18]

Later in the colonial period, rape and prostitution continued in the slave trade with Africa. In a book recently published in São Paulo, Luiz Mott quotes unpublished documents:

Among the millions of Africans brought annually from Sudan to Brazil,

at the beginning of the eighteenth century, it is calculated that in the year 1725 5,700 captives must have been landed at Rio de Janeiro.[19]

In his study the author shows us that the girl Rosa Egipcíaca was an African like millions of other women who had the misfortune to be captured and sold like human cattle in the New World, and suffer the horrors of slavery. Her first owner, who ordered her to be baptized, 'in the year of Our Lord 1725', was the one who raped her, when she was not yet fourteen.

Contemporary reports (1775) record the voluptuousness and abuse, the insatiable desire for gold and sex 'despite the anathemas of the clergy against concubinage and the mere fornication of the masters with their female slaves'. Gilberto Freire rightly remarks, 'There is no slavery without sexual depravity. It is of the essence of the system.'

No one bothered about the personal life or suffering of a poor slave, a little black girl. She was simply an object of pleasure, and all that the records contain are external descriptions of her beauty, the beauty of an adolescent girl, who, though black, has the charms and attractions to satisfy men's insatiable desires, much like the 'chicken over fifteen kilos'.

Here is one record from the period:

Twelve years is the best age for Africans. They sometimes have such charms that you forget their colour. . . . The young black girls are generally robust, solid, with features indicating pleasant amiability and all their movements full of natural grace, feet and hands beautifully formed. Their eyes send out a fire so strange, and their breasts heave with such anxious desire, that it is difficult to resist such seductions.

And here the vices recur, and the reasons are the same: wealth, represented by the gold and diamonds of Minas. A section entitled 'Prostitute in Minas Gerais' in Luiz Mott's book calls it a land of gold, diamonds and sexual liberation; women were precious objects because of their rarity. Captain Durão himself had seventy-seven male slaves and only one female slave in his mines.

It is easy to imagine what happened. A historian of the period and specialist in the religious life of this region, José Ferreira Carrato, remarks that Minas was more like Sodom and Gomorrah than the Holy Land. Of a total of 423 people denounced in eight districts of Minas at the tribunal of 1734, 95.2% of the charges began with deviations in family sexual morality, including incest, bigamy and prostitution. The author continues: 'The very sacrament of matrimony was boldly called in question.'

Irreligiousness and debauchery 'went hand in hand. A certain Antônio Araújo de Aguiar is reported to have said publicly that, 'God and the Devil had the same power, and if anything the devil was better because he gave rather than took, unlike God,' and he added maliciously, 'If God had tried sensual delights, he would not have made them a sin.'

The atmosphere was favourable to 'sexual commerce', and the slave prostitutes themselves continued the 'prostitution trade' in the goldfield region; it was an important alternative for thousands of black women who wanted to escape from servitude.

Relationships in these circumstances and this period could not be other than machista violence, debauchery and petty crime, certainly including high consumption of spirits and large doses of musk, the most popular perfume among black women in those 'bygone days'.

The fragments of historical records from various places confirm this picture of violence, subjugation and trade in what was essential if they were to survive. In 1754 a resident of Minas 'collected per week an eighth and a half (of an ounce) of gold from the activity of just one slave woman'.

At the end of this reflection I am well aware of the limits of this type of study, for the reasons mentioned at the beginning. But this is the contribution I have to offer at this stage in the history of Latin American women. There are efforts scattered about all the regions and countries of the continent, testifying to the tenacity of all the women who have already realized that their task is to contribute, to make life happen, where it is perishing. Whoever it may be, a street child, boy or girl, an indigenous person, black or white, the fact is that they are continuing to be active as 'warriors' of everyday life, using every space and every chance in the quest for their liberation, without discrimination, prostitution or rape in any shape or form.

Our moment in history is as difficult as that of our sisters in the colonial period, but we are better equipped to fight the schizophrenia of our culture that allows the coexistence of wealth and the desperate poverty of slave-owning colonialism, a scandal for a nation or a continent that calls itself civilized.

It is an urgent tsk to eradicate this new colonialism that is reappearing in the trade and enslavement of so many defenceless creatures. Much has already been done for women's liberation, but much still remains to be done.

The Latin American Women's Declaration, signed by around 3,000 women in Nairobi in 1985 at the Forum of Non-Governmental Organiza-

tions to evaluate the United Nations decade on achievements related to women, says:

> We, the women of Latin America and the Caribbean, at the Nairobi World Forum, declare before the peoples and governments of the world that the bulk of the recommendations approved in Mexico and Copenhagen have not been carried out. We continue to be faced with various forms of subordination and exploitation. We remain 'invisible' in patriarchal relations, which place obstacles in the path of our progress towards liberation. This is aggravated by the conditions in which our peoples live, affected by the most serious world crisis of capitalism. . . . The real changes in the conditions of women . . . depend on the eradication of capitalist and patriarchal structures. . . . These structures affect women both in the public sphere and in the private sphere, and we consider the democratization of social and family relations an essential task.[20]

Notes

1. Latin America, because I do not have data for the whole continent.
2. The colonial period in Brazil runs from the invasion of the country by the Portuguese and Spanish in 1500 to 1882. In other countries of the continent it begins with the arrival of Columbus in 1492.
3. S. Tomaselli and Roy Porter (ed.), *Rape*, Oxford 1986.
4. Jean Sasson, *A True Story of Life Behind the Veil in Saudi Arabia*, 1982.
5. M. Odila Leite da Silva Dias, in A. Oliveira Costa and C. Bruschini, *Uma Questão de Gênero*, São Paulo 1992, 43.
6. In 1492 there were ninety million indigenous people living in the Americas. Today there are forty-nine million, making up only 7% of the total population. In the Caribbean and Uruguay they were wiped out. See P. Suess in R. Zwetsch, *500 Anos de Invasão*, São Paulo 1992, 61.
7. A. Heller, *O Cotidiano e a História*, São Paulo 1992, 41.
8. O. Ortega, 'Mulheres Latinoamericanas – Uma História de Rebelião', *Folha Mulher* No 5, Year 3, 1992, 13.
9. M. E. Mannarelli, 'Perú: Nueva identidad femenina tras la conquista', *Conspirando: Revista Latinoamericana de Ecofeminismo, Espiritualidad y Teología* 2, October 1992, 15.
10. See Ortega, 'Mulheras' (n. 8).
11. D. Ribeiro, *Os Indios e a Civilização*, Petrópolis 1982.
12. Ibid., 22.
13. Ibid.
14. Ibid., 23.

15. Cf. ibid., 27.

16. Ibid.

17. G. Dimenstein, *Meninas da Noite: A Prostituição de Meninas-Escravas no Brasil*, São Paulo 1992, 21.

18. Ibid.

19. L. Mott, *Rosa Egipcíaca, Uma Santa Africana no Brasil*, Rio de Janeiro 1993, 13. Unless otherwise stated, subsequent quotations are from this book.

20. M. García Castro, 'A Dinâmica entre Classe e Gênero na América Latina', *Mulher e Políticas Públicas*, Rio de Janeiro 1991, 63.

Violence and Justice

Beatrix Schiele

Both the black and the white women's movement has focussed the question how it is possible for human beings to do violence to other human beings on the question why and how it is possible for societies to allow violence, especially against women and those who form part of populations of colour. So this article aims to show, first, to what extent the problem of violence against women is a political matter, and, secondly, why women's experiences of racism, heterosexualism, colonialism, militarism, economic exploitation and so on lead to the thesis that our Western industrial societies (and not only these) even need particular forms of violence in order to exist.

'When is a catastrophe a misfortune and when is it injustice?', asks Judith N. Shklar in the first sentence of her book on injustice.[1] Her investigations into the moral sense of injustice show how while philosophers talk a lot about justice, they say little about injustice and what it consists of, or how it emerges. That happens even though reflection on justice has always grown out of experiences of its opposite.

Not only natural catastrophes, like earthquakes and devastating storms, automatically raise the question of the justice of God and of one's fellow human beings. If we put this question in respect of human beings in the same way as we do in respect of certain natural occurrences, we immediately arrive at the political side of the problem of injustice and its opposite. Whom does a society abandon to their fate and whom not, and what natural events emerge in their true light as a blow of fate only in and through society? The question we are concerned with here is: when is it a misfortune to be a woman, to have black skin, to be lesbian or homosexual or old, and when is is an injustice? Many Jewish men, at any rate, thank God that they were not born women, and in America in the time of slavery

(and perhaps even today) whites aware of their election thank God that they were not brought into the world as negroes.

The experiences of violence by black and white women usually coincide with experiences of the lack of justice. What Shklar says of philosophy can also be said of university theology, with the exception of the relatively new tradition of liberation theology.[2] As though people were too refined to talk of injustice, the white theology which is practised has left behind the tradition in the Hebrew Bible of a remorseless confrontation with injustice. There prophets rage and curse at the scandal of oppression and humiliation, at unjust rulers and the absence of justice. Because they are aware that they are in the image of God they lament, and they lament because they do not want to forget the promise of God's justice.

In what follows I shall sketch out three faces of violence that emerge in the form of an enforced helplessness which needs a political answer. Because space is restricted, I can only touch on the way in which they appear in the lives of women with skin of a different colour and with a different origin.

I Faces of violence

1. Loss of rights and influence as violence

In her book *The Second Sex* – a first theoretical work on the connection between the biological fate of the woman and the structural capital which white males have made of it – Simone de Beauvoir demonstrates very vividly the difference between natural catastrophe and injustice in the relationship between the sexes. Nevertheless, de Beauvoir's condition for a complete subjecthood of women must be regarded as no less unfortunate. Woman's subjectivity is to be possible only through the renunciation of motherhood, which usually proves to be an almost insuperable obstacle to a woman's professional advancement and future security. Is childlessness as a condition of feminine freedom and subjectivity a woman's fate or an injustice? As a rule, a childless black woman is not essentially better off, and in some countries she is even worse off. The new women's movement is not satisfied with de Beauvoir's solution, and is still fighting for an end to this fate and against structural conditions which compel women to renounce much that is pleasant and many spheres of action.

In the history of those nations and former colonial powers which today are still seeking to exercise their influence throughout the world and to

stabilize it, people have constantly attempted to mitigate the misfortune of not being white or noble or male or young or heterosexual, and to change the conditions which if left as they are will lead to misfortune. As far as the relationship between the sexes is concerned, it only became clear to women in Europe after they had fought alongside men for freedom, equality and brotherhood that that brotherhood was meant literally, and that their brothers-in-arms really wanted to give the rights that had been gained only to brothers. The right to vote, the political mandate, education, to name only a few, were barred to women for more than a century afterwards. Olympe de Gouges and some others lost their lives continuing the battle for the same freedom for women. For the next two centuries women in the West had to continue to fight bitterly to gain every centimetre of equal rights – with white males. When Simone de Beauvoir wrote *The Second Sex* she did not yet have the right to vote in France. Even today women all over the world are struggling in vain for the same protection of their freedom and dignity that men enjoy. Women still do not have the freedom to go out alone at night without fear. And readiness to protect them and acknowledge their rights varies, depending on the skin colour and ethnic background of the person concerned.

It is the similarity between manifest violence and overbearing presumption which has motivated the various liberation movements to extend the concept of violence. Violence is not just a kind of brute treatment which simply offends against good manners. The political function of violence is certainly not perceptible only when one state declares war on another. Violence is also practised when people in the helplessness which has been forced on them are expected to tolerate things that are unworthy of human beings, where lack of influence is made an ongoing situation and people can only get justice, if at all, at high risk to themselves. The violent element in an injustice becomes evident where conditions which could be changed politically are allowed to continue although they cause suffering, and where reasons to justify them are constructed: for example the lack of certain freedoms because of certain physical characteristics, where women are exposed to threats without any protection unless they watch out for themselves, in other words, restrict themselves for fear of their own freedom.

2. *The politics of difference as violence*

The logic of any grounds of justification is simple. Any concern to justify a differentiated distribution of property must derive it from differences in

the gifts and endowments of those concerned. Since biological differences as a rule are immutable, they guarantee the possibililty of calculation and stability. Thus it proved expedient to establish a science which provided reasons that seemed plausible, whether these were the insights of Möbius into female lunacy, the remarks of moral theologians about the moral incompetence of women, and in our century the racist research into intelligence and gifts, Nazi eugenics. Even now, in a more or less explicit way sex, skin colouring or race, physical characteristics, sexual orientation, cultural origin, family background and so on keep being regarded as criteria for justice or injustice.

European women and men had already been trained in racist thought before the enslaving of millions of African men and women. Belief in something like a better human quality was expressed in an orientation on the supposedly blue blood of the nobility which was supported even by the church; this 'blue blood' was the decisive factor in having status and power, and not at all the fact that every woman and every man are made in the image of God and have their own individual endowments.

It has already been evident for a long time that black women and women of colour are back at a place which white women have successfully left behind. (Some activities which white women above all do and did are now also being taken on by black men.) They usually do this out of existential necessity and because as a result of a centuries-long domination the advance of the whites can always be played off against them. Thus white women everywhere, even if they largely suffer under the predominant sexism, profit from contempt for black men and black women, who are right at the bottom of the hierarchy of respect, regardless of the fact that some black people and people of colour have achieved the ascent into higher realms.

If a state wanted to be just, it would have to establish laws and structures which made it possible for individuals to repel assaults on their physical wellbeing, laws and measures which did not allow anyone to suffer disadvantage because of characteristics and chances of birth about which he or she could do nothing.[3] In just conditions it is possible for those who are affected by the consequences and side-effects of the actions of others to gain influence, be heard and make objections. One might think here of the death of 150,000 people as a result of nuclear testing. No one informed them and asked them whether they were prepared to accept this health risk.[4] (And what end could justify the means of a nuclear explosion?) In just conditions women have real alternatives between, for example,

prostitution for tourists from the well-to-do countries and productive work with a fair wage. In just conditions attempts would be made to tackle a phenomenon of bodily violence which Audre Lorde reports, namely that 'for non-white women here there is an 80% mortality rate in cases of breast cancer; there are three times as many unnecessary cases of prolapses, hysterectomies and sterilizations as with white women; and there is three times the probability of being raped, murdered or attacked'.[5]

3. The violence of non-violent resistance and the non-violence of sexual coercion

If we connect the phenomenon of violence with the question whether there is any reason which could justify compelling anyone to tolerate any kind of invasion of her or his body, we are also implicitly raising a question about the justice of violence and the silence about it. Can a situation be imagined apart from self-defence in which it seems right to say that someone has simply deserved to suffer this or that violent act?[6] For example, if a woman is compelled to tolerate a man finding sexual satisfaction from her, on what presuppositions could one say that it was probably her own fault, or that she got what she deserved, and that the one doing violence to her was quite entitled to or at least had no alternative? German law in cases of rape and also investigations of victims indicate that a readiness to acknowledge that a woman has been a rape victim decreases proportionately to her deviation from the role she is expected to play.

The following norm from German criminal law is worth discussing briefly, first as an example of the way in which white men safeguard power over women by law and jurisprudence, and secondly, as an example of the legitimacy of speaking of a violence which is desired structurally.

Clause 240 of the German code of criminal law threatens with punishment anyone who 'coerces another contrary to the law, by violence or by the threat of a tangible evil, to act, tolerate or allow'. The law is there to protect freedom of decision and action.[7] The acts punishable under this law passed by the German Supreme Court include what we know as forms of civil disobedience. Thus for example students interrupting a lecture with loud shouting are coercing forcibly, as is a predestrian who stands in a parking space and does not move because she wants to keep it free for someone, and so too is anyone who sits in front of the gate of a

barracks and does not move with the intention of preventing the stationing of nuclear mid-range missiles there.

By contrast, a man who drives his car so near to a tree that his woman passenger cannot get out is not yet committing a violent act in the sense of the law. Nor is he even if he wants to prevent his passenger from getting out with sexual intent. The moment that the violence of a man is declared violence aimed at a sexual experience, quite different criteria apply. Whereas a man who grasps a woman's breasts in passing is not deemed to be acting violently, a person who snatches someone else's briefcase and goes off with it is classified as violent and therefore prosecuted for robbery and not for theft.[8] As penal law starts from the presumption that the man makes the first move in a sexual encounter, it only makes this move criminal if he does not desist from his action despite resistance from the woman. The man who grabs a woman's sexual parts in passing is not committing any criminal act against the right to sexual self-determination because he has not overcome any resistance. For a legal formula called *vis haud ingrata* (violence which is not unwelcome) allows the man a considerable degree of compulsion and domination to make the object of his desires permit what he wants. The permissible potential of violence in the construction of criminal acts against sexual self-determination is considerable. First there is the male definition of violence, which distinguishes between violence and 'force which is not unwelcome'; indeed the idea of 'force which is not unwelcome' is first introduced as an academic category. Secondly, almost exclusively men have the power of decision in the courts. Furthermore, a prosecutor decides in advance before pressing a charge whether the woman can be believed. Even after this preliminary decision by the prosecutor, most male defendants are acquitted.

II Political violence

When there is talk of the political significance of violence in the women's movement, the following types of violence are being envisaged; at the same time they are perceived as historical phenomena of male domination:

1. In a state, ways and means are organized of compelling people through physical and psychological punishment to behave in a particular way (bugging operations, supervision, brute force, concentration camps, rape, torture, etc.). Despite eloquent lip service, however, such practices have rarely prevented democratic states from doing business with such

countries, usually because certain rights of others do not need to be recognized in them, and therefore the scope for action is wider than in one's own country.

2. A state gives itself laws or structures which deny universal rights to particular groups of people, e.g. the right to vote, education, the possession of property, the right to medical care, to work, to self-determination in sleeping together in marriage, women's right of movement, the right to birth control, homosexual love, etc.

3. In a state, laws which are intended to protect the rights of citizens are applied group-specifically. In other words, for example it is largely accepted that violence against blacks or foreigners will not be punished to the same degree as violence against whites or natives, or that sexual violence by fathers against their children will neither be punished nor stopped, whereas anyone who uses the same violence against persons outside the family is punished, and so on.

Susan Brownmiller has an illuminating discussion of the phenomenon of the various reactions to sexual violence depending on the skin colour of the victim and the perpetrator. If the victim is white and the perpetrator is black, the sanctions are far harsher than if the victim is black and the perpetrator white. We also come up against this difference in the readiness to report a crime. Victims of rape who are black generally play a lesser role when it comes to giving information and documentation of inter-racial rapes. And in the German translation of *Against Our Will* the seventh chapter, 'A Question of Race' has been omitted as if it were of no interest to us in the German-speaking lands of Europe.[9] There is not even any indication in the German edition that it is missing.

4. A state counters only those forms of violence which damage its interests. Thus, for example, in most industrial states a businessman's briefcase is protected better than a woman's inviolability. In most of these states native citizens can also be prosecuted for crimes which they commit abroad. Thus for example German or Irish women are prosecuted if they have an abortion abroad, because of a concern to protect unborn life. However, not enough care is taken to see that those tens of thousands of children who die every day of hunger and underprovision of medicine benefit from this ethic. Furthermore, no instances are known in which Irish or Geman males who have had intercourse with an under-age

prostitute in a developing country have had to answer a charge of sexual misconduct with a minor on their return home.

5. A state rates profit-orientated, material values which favour a free market economy higher than the provision of basic needs of all. Even if such states claim to treat everyone in accordance with the values they acknowledge, they do little to protect some from the misuse of the advantages which others enjoy. This is a phenomenon which can be observed particularly clearly in the different species of colonialism old and new. Thus for example European and US businesses are not obliged to grant the same working conditions as at home, even in their branches in Third World countries. And we know of no case in which, when workers have been exposed at their work-place to substances which have damaged their health, the manager has been prosecuted at home, say, for causing bodily harm. Indeed, it is well known that firms from industrial countries set up branches in poor countries in particular, where they need not expend money or effort in protecting their employees from accidents and damage to health, or give them a proper wage and sickness insurance.

6. In particular through tax relief, states encourage only lifelong associations between heterosexual couples, even if they are childless. By contrast, partnerships between couples of the same sex have far less state privilege, whether these are religious orders or lesbian and other close relationships.

Although every second to fourth marriage ends in divorce, depending on the country, and therefore millions of women have to look after their children as single parents, the structural conditions are based on the assumption that all heterosexual marriages last until death, and that women have nothing to do but care for their children. But in fact mothers bringing up children alone usually have a bare minimum to exist on. This applies especially to rich Germany, where administrative obstacles are placed in the way of day-care centres. Consequently, it is almost impossible for mothers bringing up children by themselves to earn a wage. As a result, women are often compelled to persist with a marriage which is really too much for them to bear. In poorer countries it is a luxury for women to look after their children, which is the ideal of white psychologists, since they have to spend the day getting food for their families.

III Ways out of violence

This section is concerned to identify some points at which the network of

violence could be broken. These are insights and proposals which are mentioned time and again in texts produced by the women's movement.

(*a*) Not least because women are less active in public than men, they seem less violent than the latter. In keeping out of the violent actions of their sons and partners, however, many women are defending them or even bearing responsibility for the action. So in the mass of women we often cannot distinguish whether some are deliberately non-violent and others are indifferent, have too much asked of them, or in particular cases assent to the violence. Jane Meyerding has rightly pointed out that violence and non-violence are two tactical categories which are opposed to passivity and inactivity. A non-violent action is not passive, and inactivity is not in itself a non-violent action.[10] That does not mean that every woman must become a politician in public. But if she can, every woman should take on some form of responsibility outside her private sphere. The first and most important act in public life is to stop keeping silent about what she sees outside.

(*b*) We have seen for a long time that far more than a belief that it is contrary to the will of God the Creator lies behind the rejection of homosexual love. Many sources indicate the difficulties of imagining sexuality other than in a hierarchy of man and woman. On the one hand lesbian love shows that there is such a thing as feminine sexual desire which does not need devotion to a male nor even conquest by him, and on the other hand homosexual love threatens to undermine the male rivalry for power which is so important for the success of a dominant patriarchate. We can learn something from the conflicts over homosexual love. They teach us, for example, about the way sexuality actually functions in our society and about the first condition of human sexuality, which should be a refusal to make the other person the object of one's own need for satisfaction.

(*c*) People like Marcuse at one time, and now others, should not only write about the utopian function of the feminine side but also consider what that means in practice.[11] Often competences granted to women by the dominant powers underlie feminine forces. At the same time, for centuries women have been prevented from displaying this or that power by force or by ingenuity. So where are the recipes to come from which could transform those forces into powers to save the world? Whether women can put their utopias into practice also depends on men. Finally, men should get to know

some writings from the women's movement, and argue with them. Nor should they delegate what they regard as feminine competence only to women; they should adopt these capacities themselves if they already think they might offer the hope of a better world.

(*d*) Unsatisfied basic needs already represent a state of violence. Women's visions of a society do not have much to do with concepts of integration into a world market. 'We want a world in which basic needs become basic rights,' states DAWN, a project of women scholars and activists from various countries of the South.[12] They rightly reject a strategy of basic needs which is above all concerned to integrate poor women into the market without shaking the social and sexual conditions in which power is exercised. Instead they insist on the beginnings of an independent national development and the possibility of self-sufficiency. If women of the Third World need protection for their resources (above all land, water, wood, clothing) in order to safeguard their livelihood, women of the First World need the right to earn their living for the same purpose (food, housing, clothing). If that is to be done, a much stronger commitment is needed than hitherto. Women of the Third World have some advantages over women of the First World here.[13] There can be no freedom for women unless they have a right to paid work (which can also be paid housework) and a right to land on which they can build.

(*e*) Similarly, a woman is only free if she can go down the street at night without being anxious. It is a scandal that our prosperous society has got used to the fact that women have to take care not to be raped. Because women are still trained to be ashamed of themselves if they have become victims of sexual violence, perpetrators of rape can rest confidently because their victims keep quiet out of shame. So women must constantly document and put into practice the fact that they refuse to be made victims. 'Our nonviolent project is to find the social, sexual, political and cultural forms which repudiate our programmed submissive behaviours, so that male aggression can find no dead flesh on which to feast.'[14] We cannot be against violence unless we always point it out wherever we see it. We must avoid the danger of ceasing to talk about scandal because already we can no longer perceive it. Commitment to a life without fear cannot be put on the agenda as a value worth maintaining. Constantly to be afraid is not at all boring, but a monstrous injustice.

The same thing is true of the violence of prostitution tourists. White women are wrong if they think that the exploitation and rape of women of

colour has nothing to do with them. It does, if their husbands, fathers, brothers fly abroad to these wretched prostitutes, since if they do so they are expressing what they are looking for in women, and moreover showing that they are not prepared to give up the sexual exploitation of women.

(*f*) When white people struggle with racism, they look above all at the unjust situation of the victims. In so doing we learn little of their subjectivity, their history, culture, creations, projects and competences. It would be advisable to make the competition of those whose skin is not white a topic of discussion about racism, as well as the forms of devaluation, exclusion and objectification. Racism can be seen as a primitive way of getting rid of competition, and behind it there perhaps lurks anxiety about what perhaps might be quite different creativity, different gifts and powers.

(*g*) A Christian theology, above all a theological anthropology practised by white males, must finally subject itself to a criticism of male self-definition. As long as men call for the subjection of women as necessary for their own identity as men, their concern is to safeguard their domination at the expense of more important tasks in this world. They should stop using the maleness of Jesus to legitimate their concern for domination and rather use it as a model of successful maleness.

Translated by John Bowden

Notes

1. Judith N. Shklar, *Faces of Injustice*, New Haven and London 1990.
2. Shklar also found little on the theme of justice in Augustine and Thomas Aquinas.
3. Otfried Höffe, *Politische Gerechtigkeit. Grundlegung einer kritischen Philosophie von Recht und Staat*, Frankfurt 1987.
4. Cf. Helke Sander, '150,000 Tote und Politische Utopien', in Antje Volmer (ed.), *Kein Wunderland für Alice? Frauenutopien*, Hamburg 1986, 94.
5. Audre Lorde, 'Offener Brief an Mary Daly', in ead., *Lichtflut. Neue Texte und Gedichte*, Munich 1988, 17.
6. Beatrix Schiele, 'Die Gewalt gegen Frauen als Herausforderung einer Feministischen Ethik', *Schlangenbrut* 9, 1991, no. 35, 6–12.
7. Dreher/Tröndle, *Strafgesetzbuch und Nebengesetze*, [45]1991, $240, 1f.
8. Ibid., 140.
9. Susan Brownmiller, *Against Our Will. Men, Women and Rape*, New York 1975, 210–55.

10. Ead., 'In Response. On Nonviolence and Feminism', *Trivia* 5, 1984, Fall, 60.

11. Herbert Marcuse, 'Marxismus und Feminismus', in id., *Messungen*, Frankfurt 1975, 17ff.

12. DAWN (Development Alternatives with Women for a New Era), *Development, Crises and Alternative Visions. Third World Women's Perspectives*, Stavanger 1985, 73.

13. C. Wichterich, *Die Erde bemuttern. Frauen und Okologie nach dem Erdgipfel in Rio*, ed. Heinrich Böll Stiftung, Cologne 1992, 56.

14. Andrea Dworkin, *Our Blood: Prophecies and Discourses on Sexual Politics*, New York 1976, 72.

African-American Women in Three Contexts of Domestic Violence

Delores S. Williams

Black women's experiences with violence have ranged far beyond their homes. Historically, African-American women have suffered violence in three domestic contexts. In contra-distinction to international environments, black women have met with violence in the domestic context of North America. They have also experienced violence working in the homes of white female and male employers in the United States. And they have suffered violence in their own homes and communities.

In their writings and personal testimonies, black women have revealed the various strategies they used to deal with this violence. They have resorted to legal procedures. Some of them have used public rhetoric and polemic to try to motivate other groups in the society to do something about the violence black women experience. Some have used home-spun folk remedies to threaten those who attempt to violate them. Some black women have told their stories to each other and therefore shared ways of confronting violence.

This article will describe the violence black women have experienced and do experience in each of the three domestic contexts. Brief mention will be made of the strategies some black women have used to deal with this violence. Finally I give attention to what I believe to be a primary contributor to the perpetuation of the abuse black women have experienced in the three domestic contexts.

The aim of the article is not to romanticize black women's way of dealing with domestic violence. Nor do I mean to suggest that *all* African-American women are successful in their struggle with abuse. An alarming statistic released in July 1993 on New York television discourages romantic

and stereotypical notions about black women being so strong they can confront and survive all abuse. The news person reported that last year in America forty-eight per cent of the deaths of black women under forty years old were due to domestic violence, i.e., violence in black women's homes. But any discussion of African-American women's experience with violence in their homes and communities must take seriously the long history of national violence directed toward black women and black men.

Beginning with slavery

Public violence to black women's bodies began early in American history when auction blocks were established for the sale of black slaves. During sales, black women were often stripped to the waist so that their breasts could be examined and other parts of their bodies could be viewed by potential buyers in order to speculate about the childbearing capacity of female slaves. Buyers had no concern for the violation this public inspection of black women's bodies inflicted upon black women's spirits. Neither did buyers care that their rough handling of black women's bodies often bruised the women. There were also public places where recalcitrant slaves were taken to be beaten if their masters deemed a beating necessary but did not want to do it themselves. Black women were not exempt from this kind of treatment.

After slavery, when reconstruction ended (1877), the Jim Crow laws were passed in the South, making segregation of the races legal. Some black women experienced public displays of violence at the hands of white people enforcing these laws. One such woman was Ida B. Wells, who was travelling by train in Tennessee in 1884. Sitting in the car designated first class, Wells was approached by the conductor who told her she would have to move to the car assigned for coloured people. She refused to move, for she had been sold a first-class ticket. With the affirmation of the white passengers, the conductor brought in a baggageman, who helped him drag Wells out of the coach. Wells responded to this violence and humiliation by suing the railroad. In the circuit court she won her suit. But in the state supreme court the railroad won its appeal, mainly because it falsified the evidence.

Other forms of violence in the domestic precincts of the American South affected black women and black men. Lynching of black people by white mobs was widespread in the South after reconstruction until the waning of the 1960s civil rights movements. While black men have been lynched in

large numbers, black women were also lynched. Ida B. Wells' essay 'Lynch Law', written in 1893, contains a passage describing the lynching of black females by white mobs:

> The women of the race have not escaped the fury of the mob. In Jackson, Tennessee, in the summer of 1886, a white woman died of poisoning. Her black cook was . . . hurried away to jail. When the mob had worked itself into the lynching pitch, she was dragged out of jail, every stitch of clothing torn from her body, and she was hung in the public court-house square in sight of everybody . . . The husband of the poisoned woman has since died a raving maniac, and his ravings showed that he, and not the poor black cook, was the poisoner of his wife.[1]

Wells also tells of '. . . a fifteen year old Negro girl . . . hanged in Rayville, Louisiana in the spring of 1892 on the same charge of poisoning white persons. There was no more proof or investigation of this case than the one in Jackson.'[2] Then there was the case of 'A Negro woman, Lou Stevens . . . hanged from a railway bridge in Hollendale, Mississippi in 1892. She was charged with being accessory to the murder of her white paramour, who had shamefully abused her.'[3] In an address at Tremont Temple in Boston in 1893, Wells told her audience that when lynchings occurred 'the power of the state, country and city, the civil authorities and the strong arm of the military power were all on the side of the mob and lawlessness'.[4]

Wells devoted much action and public rhetoric to exposing the violence done to black women and black men in the domestic United States. She concluded that lynching was '. . . a national crime and requires a national remedy'.[5] Wells left posterity an extensive and thorough record of America's history of lynching black people, women and men. Public murder of black women and men did not end with the nineteenth century. In the latter part of the twentieth century one of the most shocking lynchings, affecting the life of a black mother, occurred when her fifteen-year-old son Emmitt Till was lynched by Southern white men.

Today in America violence done to black women takes many forms. Though lynching at the hands of a mass of white people is no longer common, there is the brutality and even death that black women have experienced at the hands of policemen. A few years ago in New York an old black woman Mrs Eleanor Bumpers was killed by policemen who rushed into her home and shot her when she allegedly came at them with a knife.

Then, there is the violence in the African-American community caused by drugs made easily available to black people by forces outside the black community. African-Americans do not have the amount of money needed to supply the huge amount of drugs flooding the black community. This financing comes from beyond the community from non-black people who have large cash flows. The effect of these accessible drugs in the community has been widespread murder and other forms of violence affecting African-American women and their children.

Not only have black women had to confront violence done to them on a national scale. They also have a long history of experiencing violence in white homes where they have worked as domestics from slavery to the present.

Violence in the work-place

The slave narratives of African-American women are replete with testimonies of the violence slave women suffered in the homes of slave owners. Two kinds of physical abuse were most common. Female slaves were often stripped of their clothes and physically beaten by their slave owners. Also, they were often sexually assaulted by the males who owned them. Mary Prince's slave narrative tells of a slave woman who '. . . was stripped naked, notwithstanding her pregnancy, and . . . tied to a tree in the yard'. The slave master '. . . flogged her as hard as he could like, both with the whip and cow-skin, till she was all over streaming with blood. He rested, and then beat her again and again . . .'[6] Physical beating was common treatment for 'naughty', defiant or 'high-spirited' slave women.

Many testimonies of slave women and slave men tell about female slaves being sexually harassed and/or raped by their owners and other white men. In her narrative *Incidents in the Life of a Slave Girl*, Linda Brent describes the ingenious method she devised to prevent her sexual violation by her slave master Dr Flint. She hid in a crawl-space under her grandmother's roof for several years. Slave women had no control over their bodies; therefore they were violated at will by their white male slave owners. Wives of slave owners often contributed to this by violating the dignity of female slaves. The owners' wives stigmatized slave women for the sexual misconduct their husbands, the slave owners, directed toward female slaves. They referred to these slave women as concubines, which suggested that slave women had a choice in the matter. Mary Boykin Chesnut's *A Diary from Dixie*, beginning its entries in 1861, resorts to this practice as

the author laments the sexual relation between slave masters and slave women. Chesnut claimed: 'Under slavery, we [i.e., white women] live surrounded by prostitutes [female slaves] . . . Like patriarchs of old, our men live all in one house with their wives and their concubines.' She goes on to say that '. . . the mulattoes one sees in every family partly resemble the white children. . . . My disgust . . . is boiling over. Thank God for my country women, but alas for the men.'[7]

Though the violence black women experienced in the homes of their slave owners was more brutal, the violence black women experience today in the homes of white people for whom they work is no less insulting. In his collection of urban narratives *Drylongso*, the anthropologist John Langston Gwaltney includes the testimony of a black domestic worker who has to resort to protective measures to discourage her female employer's husband from sexually harassing her. The black woman finally used a black folk remedy to discourage the advances of this man. She says 'I had to threaten that devil [her male employer] with a pot of hot grease to get him to keep his hands to hisself.'[8]

The abuse some African-American women suffer in their homes at the hands of their male partners has much to do with the way in which many black men perceive black manhood and the threats to it.

Manhood, opportunity and control

In the 1940s the African-American male novelist Richard Wright wrote the novel *Native Son*, which projected a clear view of what Wright took to be the condition of manhood among rank-and-file, poor black males living in large urban ghettos. This book was a great success in the black community partly because of the image it projected of black manhood: oppressed, afraid and enraged. Bigger Thomas, the protagonist, was a poor black young adult living on the South Side (the ghetto) of Chicago. Inadequately educated, a school drop-out, jobless, living in one rat-infested room with his mother, brother and sister, Bigger was consumed with fear and rage. This fear and rage were manifested in 'bullying' conduct which ultimately ended in Bigger murdering two women: a rich, young white woman and his black girl friend Bessie. The white woman was murdered accidentally; Bessie's murder was wilful and brutal. It represented Bigger's effort to gain the sense of power and control he could not exert in the white world but could exert in the ghetto through his behaviour as a bully. In his daily life, Bigger was trapped in a racist

world that offered him no opportunity for advancement or self-realization.

The insight to be drawn from Wright's depiction of Bigger Thomas is that black men in American society are denied access to the legitimate avenues of quest and conquest which are thought to lead to the possession of manhood in the social world of America. Most black men are denied access to the financial resources in America which help men in their economic quest to found and head corporations, to secure adequate economic resources in order to provide for themselves and their families. They are denied the jobs and the kind of education that lead men to the top of the economic ladder.

Inasmuch as black men are denied access to some of the highest status-granting quest and conquest routes, some black men begin to regard black women as the arena of conquest. Conquering black women's bodies sexually becomes the object of the quest and the means of demonstrating strong black manhood. Black teenage pregnancies often result from this black male way of proving manhood through the conquest of black women's bodies. Fundamental to this notion of quest and conquest (as indicative of manhood) involving black women's bodies is the idea of male control of female. And this control must be publicly demonstrated in order for a man 'to be a man' in the estimation of his male peers.

This was clearly indicated in the African-American rebellion of the 1960s, when some of the black nationalists declared that a woman should walk six paces behind 'her' man, thus indicating that he was 'the boss'. It is no wonder that many black men during the 1960s and 1970s rebellion proudly repeated the declaration Eldridge Cleaver made in his book *Soul On Ice*: 'We shall have our manhood or the earth will be razed in our attempt.' If secured, this manhood would be about the business of subordinating and controlling African-American women.

When black women refuse to be the object of this conquest, when they refuse to allow black men to control them, domestic violence in the home can occur. In her book *The Habit of Surviving*, Kesho Yvonne Scott records Marilyn's story-telling of teenage pregnancy, of her effort to return to school, of the ensuing struggle with her husband

Bobby [who] reacted. He saw school as a threat to him somehow. He expected me to do everything in the house, study when he wasn't home . . . my grades started to slip, the fighting started, and all the talk about being a poet and writer . . . seemed like such a distance away. I stopped the fighting because I took everything in the house and broke

it. . . . He quit beating me. But I was already beat. So . . . I quit school. Trapped again.[9]

Certainly drugs, mental problems and experiences of abuse as children may cause some black men to resort to violence in the home that injures or kills black women. But Constance A. Bean makes a point that applies to all men, black or white, in patriarchal society. These kinds of societies sanction men's feelings that they have the right to control their families, including the women. The men feel '. . . that their male image depends on their ability to dominate and control . . .' Bean points out that 'the law often reflects male privilege, including the view that the . . . [abused] woman must somehow have been at fault for what happened to her'.[10]

With regard to African-American women, there are additional reasons that might account for the violence they continue to experience in the three domestic contexts of nation, work-place and personal abode. One of the most serious contributors to this violence is the discourse about the origin and nature of the Negro (female and male) that began in the nineteenth century in North America.

Human or beast?

The anti-black literature that circulated in America from the time of the Civil War (1863) until 1925 did much to convince the American public that the Negro – female and male – was a different order of species than 'man' (meaning white people). The Ariel controversy, beginning in print in 1867 with the appearance of a pamphlet entitled *The Negro: What Is His Ethnological Status*, raised these questions:[11] 'What is his [Negro men and women] Ethnological Status? Is he the progeny of Ham? Is he a descendant of Adam and Eve? Has he a Soul? or is he a Beast, in God's nomenclature? What is his Status as fixed in God's creation? What is his relation to the White race?'[12] Using the Bible to provide proof for the insulting responses given to these questions, Ariel concluded that the Negro was not descended from Ham because Ham was white. Interpreting the identity of the 'passengers' in Noah's ark, Ariel argues:

As the negro is not the progeny of Ham . . . and knowing that he is of neither family of Shem or Jepheth, who were white, straight haired, etc., and the negro we have now on earth, is kinky-headed and black, by this logic of facts we know, that he came out of the ark, and is a totally different race of men from the three brothers. How did he get in there,

and in what station or capacity? We answer, that he went into the ark by command of God; and as he was neither Noah, nor one of his sons, all of whom were white, then by the logic of facts, he could only enter it as a beast, and along with the beasts.[13]

According to Ariel, the negro female and male came out of the ark as beasts, and as beasts they had no souls, were not human and therefore were not the descendants of Adam and Eve. Accounting for the present appearance of the Negro as an improvement upon the beast who came out of the ark, Ariel says:

> We will begin with the cat. The cat, as a genera of a species of animals, we trace in his order of creation through various grades — cougar, panther, leopard, tiger, up to the lion, improving in each graduation from the small cat up to the lion, a noble beast . . . we take up the monkey, and trace him likewise through his upward and advancing orders – baboon, orang-utan and gorilla, up to the negro, another noble animal, the noblest of the beast creation.[14]

According to Ariel, all the humans who went on board the ark, i.e., Noah and his family, had white skin with the physical features of white people. Thus white people could not possibly be of the same species as black people. God ordained that 'man' and 'beast' belonged to two different orders of creation. 'Ariel' was but one of the pamphlets appearing during this period committed to proving Negroes were beasts.

These anti-black arguments helped to mould an American conscious-ness about the Negro that even today regards black people as beasts, female and male. Therefore, black women (and black men) can be abused and treated like animals rather than like humans. Since Ariel and other anti-black material used the Bible to substantiate their claims, they advanced the argument that God gave humans (read white people) control over all beasts, for this is recorded in the creation story in Genesis. So God intended white people to rule over or control black people. Since black women and men were animals, white people or humans could treat black people in any way that helped maintain white control. It is not hard to imagine that black women and black men experienced all kind of violence and abuse as these 'human' white people tried to maintain their God-ordained control.

Neither is it surprising that American legal and judicial officers have historically reacted with vengeance when blacks abused or killed whites,

but responded in a passive, indifferent or 'lukewarm' way when whites abused or killed black people. According to this skewed mythology about white human and black beast, the legal system could not act in any other way if its judges believed in the order of creation in the Bible as interpreted by such 'intelligent' agents as Ariel.

The violence African-American women have experienced in their homes at the hands of their male partners raises several questions when one considers the existence, nature and popularity of the Ariel literature and controversy. Does the black male 'control mentality' that incites the violence males inflict upon black women have kinship with the 'control mentality' of white people (thought by Ariel to be human) that inflicts violence upon black people (thought by Ariel to be beasts)? Have some black men, in their violation of black women, internalized this Ariel view of humanity and beast, appropriating humanity for themselves and beasts for black women? Does the African-American community need to turn its attention to the re-definition of black manhood so that black women will be freed from violence in their homes and communities?

In the final analysis African-American women must defend themselves against the violence they are likely to experience in the three contexts of nation, work and home. One of the ablest defences is a united sisterhood dedicated to securing the life, health and well-being of black women. If it is true, as Toni Morrison says, that African-American women have no one to defend them and may have invented themselves, it is all together fitting and proper for black women to protect their invention. They must use all their resources – God, church, school, education, politics – to survive and help each other survive.

Notes

1. Ida B. Wells, 'Lynch Law', in Darlene Clark Hine (ed.), *Black Women in United States History*, Vol. 15, Brooklyn, New York 1990, 197.

2. Ibid., 197–8.

3. Ibid.

4. Ida B. Wells, 'Lynch Law in all Its Phases', in Darlene Clark Hine (ed.). *Black Women in United States History*, Vol. 15, Brooklyn, New York 1990, 176.

5. Ida Wells, 'Lynching: Our National Crime', *National Negro Conference: Proceedings*, New York 1909, 174–9.

6. Mary Prince, 'The History of Mary Prince, A West Indian Slave', in Henry Lewis Gates, Jr (ed.), *Six Women's Slave Narratives*, New York, first published London 1731, 7.

7. Mary Boykin Chesnut, *A Diary From Dixie* (1905) Cambridge, Mass. 1961, 21–2.

8. John Langston Gwaltney, *Drylongso*, New York 1980, 150.

9. Kesho Yvonne Scott, *The Habit of Surviving*, New Brunswick and London 1991, 30.

10. Constance A. Bean, *Women Murdered by the Men They Loved*, New York 1992, 44.

11. This controversy got its name from the author's pseudonym, which was given as Ariel.

12. For the complete text of the Ariel controversy and other anti-black literature during this period see John David Smith, *Anti-Black Thought, 1863–1925*, Vols 5 and 6, New York.

13. Ibid., 20.

14. Ibid., 22–3.

Feminine Socialization: Women as Victims and Collaborators

Mary John Mananzan

Introduction

One of the self-perpetuating features of an oppressed consciousness is its lack of consciousness of its being oppressed. This initiates a vicious cycle with the oppressed continuing their own oppression and the oppression of those of their own kind. This is true in the case of women, who have so internalized their own oppression that they are not only victims; they are unwitting collaborators in their continued discrimination, subordination and exploitation. However, right from the start, I would like to differentiate this statement from the practice of blaming the victim. To discuss the socialization of women is not to impute guilt but to explain how, even without fault on their part, they are conditioned to be prone to victimization, and how because of their lack of consciousness, they transfer this proneness to the next generation. But before going into a theoretical discussion of the phenomenon, it is good to observe this in actual stories of women.

Women's Stories

1. *Diding*

Diding is a peasant woman from the southern Philippine island of Leyte. She learned about the peasant women organization, Amihan, and joined it. In one of the conferences of the organization, the national chairperson of Gabriela was invited to give the keynote address. During the noon break, she found herself relaxing in one corner with Diding. She asked her,

'Diding, has there been a change in your life now that you are a member of Amihan?' Diding replied, 'Oh yes, definitely. My husband does not beat me up any more. Pressed for an explanation, Diding elaborated: 'Before I joined Amihan, I thought my husband had the right to beat me up when I answered him back during our quarrels. Now I know that he has no right to beat me up. So one day, I confronted him, I said, "You have your human dignity, I respect that, but I also have mine. This must stop." Since then he has not beaten me up anymore. Because I also told him: "If you ever beat me up again, I am going to leave you".'

2. Emma

Emma was thirteen when Pedro, a thirty-year-old married man, seduced her. Thinking that losing her virginity made her worthless, she agreed to live with him as his mistress. Pedro is a very jealous man and used to lock Emma up in the house when he went to work. On Emma's second pregnancy, Pedro became jealous of their landlord and started to beat Emma up, grabbing her hair, bashing her head on the floor or on the wall. One day he knocked her about so badly that she lost her three front teeth. At the birth of their child, during one of his rages, Pedro threatened Emma with his home-made gun called *sumpit*, with pellets as bullets. The gun actually went off and embedded nine pellets in Emma's thighs. Seven of the bullets were taken out in a painful operation but two remained embedded in her thigh-bone. She was referred to the Women's Crisis Center, where she lived with her children for about a year. A case was filed against Pedro which was not the first one, because when he seduced Emma when she was thirteen, the employer of Emma had filed a case against him then; however, this which was dismissed because Emma said she loved Pedro and went to live with him. Unfortunately, after living in the centre for a year, Emma met Pedro again. Once more she withdrew the case against him filed by the centre and returned to live with him. Now he comes and goes, and every time he comes, Emma has to sleep with him. She has just given birth to her fourth child at the age of twenty-five. She lives in constant fear of him. When asked why she does not leave him, she says she depends on the Pl.500 ($75) he gives her monthly for the children support, and because she is afraid that the next time she leaves he would again look for her and might kill her and her children.

3. Fatima

Fatima is a Pakistani woman, daughter of a serf who was married to

another serf through the agreement of their landlords – typical practice in a feudal set-up. The couple had two daughters. But the husband frequently beat up his wife, whether he was drunk or just in a bad mood. Fatima suffered for fourteen years until she could take no more. One evening, after a particularly inhuman beating, she took her daughters and fled to her former master. He welcomed them and gave them shelter. He had last seen her as a child bride, and now she has grown to be a beautiful woman. One night, he sent for her, ostensibly to discuss the settlement to be made concerning her marriage, but at the end he raped her. Her whole world came crashing down. She had no place to go. So when he sent for her again and again, she had no choice but to endure his callousness. Then, one day, he said he would send for her husband, whom he thought must have come to his senses. Dreading the thought of going back to her husband, she decided to run away again with her children and turned up at the doorstep of the wife of another landlord. This good woman bundled them off and sent them to a friend in another part of the country where they now live with new names and new identities.

When we reflect on these stories, some questions come to mind. Why did Diding think it was all right for her husband to beat her up when she answered him back? Why did Emma think she had become completely worthless when she lost her virginity? Why did she go back to Pedro again? Why did Fatima endure fourteen years of maltreatment from her husband? The answers to these questions lie in the gender socialization of women and of men.

Patriarchy, the root of violence against women

In ancient societies, for example among the Hebrews and the Romans, the father of the famiy had absolute rights over the members of the family. As patriarch, he owned not only the house, the lands, the animals, the slaves, but also the wife, the concubines and the children. In the Bible we read how a father could offer his daughter to be raped by the townspeople instead of his guest (Judges 19.24). Although practically all societies would no longer recognize this 'right of ownership' of people, the sense of proprietorship of men over woman, especially those dependent on them, still exists in the hard disc of their psyche. This came home to me very strongly when a father who was apprehended by the police for molesting

his eight-year-old daughter said: 'She is mine. I produced her. I have the right to her before anybody else.' It is the same proprietorship that makes a man feel he can beat up his wife or children. It must also be somehow in the consciousness of the rapist, who thinks that he has a right to take something from a woman whom he can overpower.

How about the 'right' a conquering army feels to rape the women of a nation they have defeated? From the battles of ancient times to the Bosnian-Serbian conflict, women of defeated countries or peoples have to bear the brunt of the ignominy of their defeat by suffering the sexual assault of the victors.

Patriarchy indeed provides the condition for the possibility of ongoing violence against women, as is explained in the following:

> Patriarchy is a social system which supports and authenticates the predominance of men, brings about a concentration of power and privilege in the hands of men, and, consequently, leads to the control and subordination of women, generating social inequality between the sexes.
>
> This disparity of power, privilege and prestige entrenches and perpetuates patriarchy in society. It gives men power, domination and advantage over women and explains much of the continuing violence. (*Committee*, 48).

Why is it that even after slavery has been condemned by all nations, the victimization of women in its myriad forms is still tolerated or taken as a fact of life in our societies? This brings us to the all-pervasive and continuous socialization of both men and women that perpetuates the situation.

Socialization in the family

The family is the first place where the child absorbs by osmosis biases, fears, prejudices. In the attitude of the parents, in the way they act towards others, in their prohibitions and admonitions, the seeds of racism, discrimination and sexism are planted.

From early childhood, the norms by which a girl should act are implanted. She is to be quiet, unobtrusive, not boisterous. She somehow learns to be coquettish and how to please especially the opposite sex. As an adolescent, she learns that she must learn how to be attractive to men, that her highest dream is to find a prince charming, with whom, when he kisses

her, she will live happily ever after. She learns from the example of her mother and female relatives that women have to humour their husbands, that they have to be subservient to their decisions, and maybe she learns by experience the price of non-subservience – being battered verbally, psychologically and physically. She observes how men put very little value on women's opinions, and maybe even observes how women are belittled, ignored, or taken for granted. She sees how everybody must keep quiet when the father is taking a nap, how everyone must tiptoe around the father when he is in a bad mood – how meals, trips, or other arrangements must revolve around his convenience or wishes.

It is in the family that the girl is socialized into her role as wife and mother, beginning from the time she received her first doll or tea set and began to play 'house-house'. She is conditioned to think that maternity is what gives her worth when married, just as virginity makes her valuable before marriage. The care and education of children is put in a whole package, beginning with pregnancy, and is handed to the women as her main role. She is conditioned to think that she is responsible for the success or failure of her marriage and that whatever success she may experience in her life. If somehow her marriage does not work, she is a failure. Many a wife-battering is justified because a woman fails to comply with the image of a subservient 'good housewife'. She also feels so much guilt when she somehow fails the expectation of her husband and other people that she even excuses her husband's violence. The fact that a 'broken home' is a failure that would be put at her door also makes her hesitate to separate from a violent husband. So she endures long years of humiliation and pain 'for the sake of the children'.

The Social Affairs Committee of the Assembly of Quebec Bishops point out the importance of the family in the socialization of girls:

We recognize the vital influence of what we learn at an early age and of our first significant affective relationships. Depending on whether we live these experiences in an environment where control and force prevail, or in one that thrives on mutual respect and understanding, we develop differently as individuals, with different ways of relating to others. How many children learn to accept family violence as a fact of life and hence to justify men's violent treatment of women? These children become adults burdened with unmet needs, ill-equipped to express their feelings and frustrations. They know no other means but violence to express their anguish. Thus another link is forged in an endless chain (33).

Studies have shown that fifty per cent of batterers were battered as children. Fifty-two per cent witnessed violent behaviour in their original families (Linda McLeod, 23).

Socialization in society

Cultural values and attitudes towards women pervade not only the home but the society at large. Two of the most important socializing agents in society are the school and mass media.

Traditional schooling confirms and continues the stereotyping of roles begun in the home. Certain subject courses like mathematics, gardening, engineering, etc., are considered appropriate for boys, and home economics, marriage class, etc., for girls. Textbooks are sexist not only in content but also in illustrations and in language. An illustration entitled 'A Happy Family' shows the father looking at the television or reading a newspaper, the son playing with toy tanks, and the mother and daughter setting the table. The mainstream of the different disciplines are usually *malestream*. History books are written as though only men made history. Psychology, economics, law, social sciences, technical subjects, etc., are usually gender-blind. Scholarly researchers do not reflect the perspective of women. In other words, men's experiences, men's ways of knowing, male methodologies have been universalized as human experience, human epistemology, scientific method and human knowledge.

In this age of information and technology mass media is a very powerful means of socialization. Sex and violence are the main selling features of movies and TV programmes. Advertisements not only make women commodities, they portray them in indecent poses, in subservient roles. They glorify but at the same time trivialize domestic work with 'magic detergents' and super-efficient appliances.

Action movies focus on criminality, extra-judicial solutions and violence against women and children, and mesmerize male audiences with display of complicated super-weapons of destruction and killing. Pornography is most especially reprehensible, not because it is 'indecent' or 'shows explicit sex', but because it shows the degradation of woman physically and sexually. When men feed daily on such films and programmes, actual violence against women in real life is trivialized.

Print media are no better, as is shown by Arche Ligo (1992):

The print media also contribute to the perpetuation of the victimization

of women. Tabloids have made their money on sensational news of crime, violence and sex. Their headlines are very graphic, and front-page pictures gory and lewd. Rape cases often grab the first page or headlines in these papers. Magazines, even those that are purportedly published for women, lend themselves to the further victimization of women. By adhering to the traditional roles and fostering the stereotype images of women, they inadvertently give wrong signals to non-traditional women as well as to the traditional men. These magazines often trivialize experiences of sexual harassment and battering of women. Women who seek to please their men will not be harassed or battered, so these magazines seem to say.

The following confession of a man who attempted to rape at seventeen is shocking but revealing:

> I grabbed her from behind, and turned her around and pushed her against the wall. I'm six foot four . . . I weighed about two hundred and forty pounds at this time, and she didn't have much chance to get away from me. She tried. I pulled her back and hit her several times in the face quite hard, and she stopped resisting and said, 'All right, just don't hurt me.' And I think when she said that . . . all of a sudden a thought came into my head. My God, this is a human being . . . it was difficult for me at that time even to admit that when I was talking to a woman, I was dealing with a human being, because, if you read men's magazines, you hear about your stereo, your car, your chick . . . (quoted in Susan Griffin, 99).

Socialization of women by religion

In the first Asian consultation of women theologians held in November 1985 in Manila, twenty-seven women from seven countries coming from different religious backgrounds were unanimous in their conclusion that 'there is a religious root' to women's oppression.

The Bible is a norm of conduct for Christians. Although its main message is a liberating salvific one, its patriarchal elements have been used to rationalize the subordination and discrimination of women. The traditional interpretation of its first chapters consider woman to be secondary because she was supposed to be created from the rib of man and for the purpose of accompanying him, and she is considered to be the cause of original sin, because she 'tempted' man to disobey the command of God.

This is at the root of woman's consciousness of inferiority and guilt. A raped woman in court will be badgered by the defendant's lawyer trying to prove that by wearing an indecent dress or by being in a place at the wrong time, she somehow tempted the man to rape her.

Even though Christ showed a remarkable breakthrough in his relationship with women, his apostles did not seem to learn this aspect of his message, and very soon there was a repatriarchalization of the early church. The fathers of the church who were the first interpreters of the Gospels and were therefore normative in the life of the Church exhibited misogynism in their writings. One example suffices. Tertullian writes of woman:

> You are the Devil's gateway. You are the unsealer of that forbidden tree. You are the first deserter of the Divine Law. You are she who persuaded him whom the Devil was not valiant enough to attack. You destroyed so easily God's image, man. On account of your dessert, that is death, even the Son of God had to die (Tertullilan, *De Cultu Fem.* 1.1).

The later doctors of the church were no better. Even the great St Thomas Aquinas wrote of woman as the 'misbegotten male' or 'passive receptacle'. One can give countless examples. The point is that there is a long and continuous history of misogynism in church history which accounts for the tenacity of the interiorization of women about their inferiority, subordination and all the other stereotyped ideas about femininity which have contributed to their susceptibility for victimization.

From victim to survivor: an urgent imperative

From the foregoing, it is clear that a vicious cycle of violence against women has gone on continuously for generations. Powerful institutions – the family, educational institutions, the church and state institutions – have not only put a stop to it but have even justified and perpetuated it. Individual women themselves socialize their children or students in the way they have been conditioned. We can now answer the questions posed after the stories cited. Why did Diding think it was her husband's right to beat her up when she answered him back? Because even from the start of her marriage, she was told on her wedding day that 'she was to be subservient to her husband *in all things*'. Why did Emma feel that she was worthless when she thought she had lost her virginity? Because she was taught by her mother, by nuns and priests and by all her elders, that an

unmarried woman's pearl of great price is her virginity and that losing it is, even without her fault, 'losing her honour'. Why did she go back repeatedly to her violent husband who almost killed her? Because she had been conditioned to think that she was responsible for keeping the marriage intact, that pain, humiliation and suffering are nothing compared to a 'broken marriage'. The same reasons kept Fatima in bondage to her abusive husband for fourteen years.

Fortunately, today the women's movement has somehow succeeded in jolting the consciousness of men and women about the heinousness of the continuing violence perpetrated against women. Women's studies and women's centres have helped in prevention by education and in alleviating and rehabilitating victims of violence. There have been initiatives not only to criticize mainstream education, the traditional family values and theologies, but also towards alternative feminist education, alternative family life-styles and global efforts at a feminist theology of liberation.

It is significant that in the Women Crisis Center I am involved in, the women have refused to be called victims. They insist on calling themselves survivors, and they have formed a support group to help each other. It is true that, compared to the persistence and the frequency of cases even today, these efforts seem to be insignificant. But at least the torsion has been introduced. There is a crack in the vicious cycle. It will take the vigilance, commitment and sustained efforts of every empowered woman and of every decent men finally to make the fundamental break.

Sources

Griffin, Susan, *Rape, The Politics of Consciousness*, San Francisco 1979.

Ligo, Arche, *Theological Reflections on Violence Against Women*. An unpublished manuscript, 1993.

McLeod, Linda, *Battered But not Beaten: Preventing Wife Battering in Canada*, Ottawa: Canadian Advisory Council on the Status of Women 1987.

Profitt, Norma Jean and Naranzo, Dellanira Perez, *Tire el Silencio Afuera*, Costa Rica: Colectivo de Mujeres Pancha Carrasco 1992.

Social Affairs Committee of the Assembly of Quebec Bishops, *A Heritage of Violence*, Montreal 1989.

Wilson, Elizabeth, *What is to be done about Violence Against Women?*, Harmondsworth 1983.

Of Monsters and Dances: Masculinity, White Supremacy, Ecclesial Practice

Mark Taylor

In James Baldwin's *Going to Meet the Man* (1965), a white male sheriff feels his masculinity is at stake. Between the sheriff's impotence and his eventual arousal to sex with his white wife, Grace, Baldwin spins harrowing tales of black men's experience of persecution – their publicly-viewed castration, lynching and burning. These tales give vividness to often neglected pages of US history, the pages that would tell of the thousands of African-Americans subjected to the often ritual torture that resulted from white supremacist mind and practice. What is striking about Baldwin's story, however, is that this history is depicted as part of the white male's psychic and sexual memory. In fact, in Baldwin's story, playing with this repressed memory becomes the way the sheriff finally mobilizes his sexual arousal. Horrific castration, burning and lynching become, for the sheriff, sexy thoughts.[1]

Move ahead to 1990. The movie *A Bonfire of Vanities*, starring Melanie Griffith and Tom Hanks, features an early scene in which these two actors take a wrong turn in their car and end up lost along a detour through the Bronx. During the detour, the white couple, anxious to get to their 59th Street love-nest, encounter all the stereotypes of black urban life: burning car-shells (shown 3–4 in number, all in flame at once), pimps beating their reluctant prostitutes, etc. Grotesque African faces are made to menace the lovers through the car's window panes. Street toughs seem to threaten the couple, until they eventually manage a reckless escape that involves injuring one of the African-American men.

Finally, back in the love-nest, the language is itself revealing. Melanie Griffith's character undresses and sighs, 'We were in a jungle'. Hanks' character agrees, 'We could have been killed'. Then, all of Griffith's earlier, fearful panting along the way of the Bronx detour culminates in a moan: 'Ooh, this might be the best sex I've had in a long time!'

These two vignettes – one from the literary discernment of Baldwin into the sinister recesses of the white male mind, the other a seemingly unknowing display by white culture of its own racist, psycho-sexual logic – introduce my argument here. The argument is far from new for those who have been exploring the literature on connections between sexism and racism,[2] but I want to present it here to facilitate reflection on potential ecclesial responses to what is a formidable challenge.

The argument is that masculine identity in the US, often constructed in a sexist paradigm, also entails assumptions and practices of white supremacy. Put in other terms, when a white male's senses of 'being a man' are understood as being 'over and against' women, then those senses are also often nurtured by awarenesses – conscious or unconscious – that as white he has supremacy over people of colour, especially over African-Americans ('Blacks').

This subject may seem repugnant and sick to some readers and hence calls forth only denunciation and unambiguous protest. This often results not only in silence about these issues, but also in a failure to develop theories about them carefully. This article will therefore seek to develop often neglected theory here, in fact beginning with some crucial theoretical conceptions (Part I), before elaborating the argument concerning the interaction of sexism and racism as exemplified in Baldwin's text (Part II), and then proposing the kind of emancipatory praxis that might be a countervailing force (Part III).

As will become clear from commentary below, I wrestle with these issues as a white male. This social location of mine both enables certain insights into the pervasive character of white racism in the USA, and also limits my horizons. Both my insights and limited horizons, whatever they may be, mean that this article is, like all writing, an experiment awaiting future conversation, critique and tests of practice.

I A conceptual orientation

There is no one definitive conceptual framework for reflecting on the issues I take up here. It is possible, however, to identify the major terms that guide my argument conceptually.

Cultural hegemony

For both thinking about and resisting problems like sexism and racism, especially when they operate together, we need to choose our terms carefully. I will frequently be referring to the notion of 'cultural hegemony'.

While the term had been used by others earlier, it has had its richest application and influence through the writings of the Italian Marxist Antonio Gramsci.[3] In a general sense, 'hegemony' refers simply to the attainment of predominance by one group in a society. In Gramsci's sense, however, a particular social group attains this 'hegemony' when it is able to exercise control by using two kinds of power: coercive governmental power, and the power of intellectual and moral direction. The first is exercised in what we might normally refer to as the machinations of government and state force. This is often referred to as 'political society'. The second occurs through the media, the society's institutions (schools, hospitals, churches, synagogues, mosques, social services, et al.), its joking rituals, its ways of advertising, and is often referred to as 'civil society'. Hegemony, then, is exercised not just through obviously political means, but through the entirety of a society's cultural representations and practices. Hence, hegemony is not simple top-down force, it is a kind of power that pervades almost all dimensions of society and is etched into the fabric of everyday interaction and exchange. A group's hegemony may then be present not only in a new governmental policy or a President's speech, but also in Rotary Club benefits that can often display male bias in business, or in jeans commercials that glorify youth and the blond, blue-eyed look.

The implications of this notion of cultural hegemony for reflecting on sexism and racism are many; I shall comment on only two. First, it means that the study of sexism, as the abusive exercise of men who exploit their power to the detriment of women (and often themselves), cannot be content to focus on the blatant and flagrant acts of abuse. We also must focus on the subtle and widespread dissemination of practices and messages that reinforce sexist and white supremacist assumptions. White supremacy, for example, is not simply the Ku Klux Klan; it is also in the polite sophistication of Wall Street. The rap group 'Public Enemy' got it right:

If you only trust the TV and the radio
These days
You can't see who's in cahoots

'Cause now the KKK
Wears three-piece suits
It's like that y'all
In fact you know it's like that y'all.

The second implication of 'cultural hegemony' for thinking about racism and sexism should by now be clear. As hegemonic, sexism and racism are pervasive throughout the culture. It follows from this that we will find them not to be separate oppressive structures, but intertwining and overlapping dimensions in society. Racism and sexism are obviously not about the same problem, nor do they have the same dynamics; nevertheless, within a cultural hegemony that pervades political and civil societies, they can be expected always to be in interaction with each other.

One other notion also needs clarification. In many ways it is the culmination of the process of cultural hegemony. The notion is *consent*. So pervasive and powerful is a cultural hegemony that it seeks out and often creates consent to its power not only in the middle and upper ranges of a culture, but also among those who are most exploited by the group's hegemonic position. Oppression often gets internalized by victims themselves. The hegemony uses media advertising, popular literatures, styles of art and taste that not only put down the weak and powerless but also lead them to put down themselves, to demand less for themselves.

Sexism within the cultural hegemony therefore seeks the consent of women to their own exploitation. This may be done through proliferation of theories about women's ability or lack of ability, their role, religious views of their status before God, etc. White supremacism, within the cultural hegemony, a hegemony that fixates on skin-colour and negates blackness, may create in people of colour a self-disdain focussed on their own darker skin-pigmentation. In these ways and others, the 'consent' of the exploited functions to assure the hegemony's fullest extension of power in the culture, and makes enormous and complex the burden carried by oppressed groups.

Representational politics

'Representational politics' is a term increasingly used in studies of popular culture and cultural studies. It is particularly useful in relation to cultural hegemony. 'Representational politics' refers to the political effect of multifaceted representations. These representations are usually images that can be found in the media or in advertising, or narratives that have

special power in the culture, or dramatic events that have culture-wide appeal. To say that such images have a politics, or 'possess political effectivity',[4] is to acknowledge that they function in the context of power. Moreover, if this context of power is hegemonic, with particular groups commanding the most power, the images must be examined in relation to that hegemonic power. Madonna, as singer and as phenomenon, for example, is a multifaceted representation. She can be studied for her representational politics. That is, we can ask what is the political effectiveness of the Madonna complex of images, especially with respect to the empowerment of women.[5]

To study the representational politics of images is to analyse how powerful modes of 'civil society' in our everyday lives lead to empowerment or disempowerment, and for whom. In doing so, we are studying the ways culturally hegemonic practices operate in subtle forms. It is in the representational politics of a culture that the hegemony has its heart, because it is there, in the politically effective image, that forces of the 'political society' are fused with those of 'civil society' to create a comprehensive hegemonic impact.

Consequently, resistance and transformation will need to understand representational politics. Indeed, I will be suggesting that the church's response to the structural evils of racism and sexism, viewed within the cultural hegemony, will require formulating a new and emancipative 'representational politics'.

Ecclesial practice

The church, as the collective embodiment of the mystery of Christ in the world, is to unleash emancipation, or an integral freedom, for all sufferers of hegemony.[6] From this viewpoint, Christian witness and ministry have the character of an emancipatory struggle and hope. Its ecclesial practice is an emancipative practice. Because ecclesial practice is a struggle *against* and *amidst* cultural hegemony, that practice takes on a special complexity. There are three traits of ecclesial practice which are especially relevant.

First, because of the pervasive mode of power of cultural hegemony, ecclesial practice must work with a *multifaceted awareness and strategy*. It, and any other cultural efforts to resist hegemony, cannot take up only what Gramsci called 'a frontal or manoeuvred war in which one invests all one's efforts to achieve a decisive battle'.[7] Instead, what is preferable is what he terms a 'war of position', i.e. 'a slow, step-by-step conquest of one vantage point after another, realizing that the points needing challenge are

never concentrated in one place, but always dispersed, thus requiring a working on many fronts'.[8]

Second, although ecclesial practice will need to work on many fronts, it has a particular way of focussing its emancipatory struggle. I suggest *it provides images, symbols and narratives that offer a countervailing 'representational politics'*. In this way, ecclesial practice contributes to emancipation by addressing that crucial place in cultural hegemony where the politically effective image usually fuses the dynamics of political and civil societies.

Third, the fact that the pervasiveness of cultural hegemony makes ecclesial practice occur amid as well as against the hegemony, means that the church's emancipatory struggle is *never merely oppositional*. Emancipatory struggle must face the ambiguity that the hegemonic powers that are resisted are inside as well as outside the resisting ecclesial community.[9] At the close of this article, then, I will describe a countervailing emancipatory project for the church that is not simply oppositional. This will involve finding ways to bring to the surface the monsters of gender injustice and white supremacy. They cannot simply be opposed out of a moral outrage. They must be named, absorbed, re-worked – defanged, if you will. All of this takes place through a subtle and improvisational kind of emancipatory struggle that constitutes a dance. Hence, I write of monsters and dances.

II Facing the monsters – hegemonic masculinity and white supremacism

Christians engaged in emancipatory struggle amid and against hegemony do well to present the nature of the things resisted. In this section, I want to show (*a*) that there indeed exists a fusion of sexism and white supremacy in the cultural hegemony, and (*b*) how monster-making and monster-slaying constitute two crucial dynamics within hegemonic sexism and racism.

The position of 'white males'

As shown in the 1992 hit movie *Falling Down*, there is a tendency for us white males to present ourselves as the new beleaguered minority, struggling for dignity amid a multicultural sea of peoples who now want to neglect our needs. *Falling Down* is a film with which many white audiences identified as expressing their rage at intractable, urban, personal and social

problems. Lamentably, the film uses many of the worst possible stereotypes of people of colour (Koreans, Latinos/as, African Americans) to explain the leading character's rampage of rage through contemporary Los Angeles. Amid these forms of white male self-defence, the reality of the position of white males in the cultural hegemony often gets lost. 'White male' is indeed a term that has been bandied about in a flippant way as a quick referent to a category of villain. But for all that, it should not be discarded as being without meaning and reference to crucial organizations of power.

Simply look at the position of 'white males' from the perspective of income. Among people who make more than $50,000 a year, there are 8.6 million white males. That makes up 11% of all white males. If we look at the group of 'white women' we find a drastic drop there; only 1.5 million or 1.8% of their group exists in that echelon earning $50,000 or more per year. Similarly, that 11% is significantly higher than the number of black men and black women. Only 229,000 black men (2.3% of their group) and a bare 89,000 black women (.7% of all black women) make more than $50,000.[10]

For some, I am here simply confirming the obvious: that 'white male' is a designation naming a position of power. From the perspective of income, white males have a greater likelihood of gaining access to power and a greater stake in defending present structures that sustain that power. Certainly many like to say that white males can be 'benevolent', caring, using their wealth for others. Moreover, it *is* true that the majority of white males are *not* making $50,000; many are on the slopes of downward mobility, or simply down and out. This, however, need not mask the important fact that the structural opportunity to run the gamut from 'down and out', on the one side, to someone earning more than $50,000 on the other is structurally more probable for white males than for women and blacks.

If we keep in mind the workings of hegemony, these economic realities do not just mean a tyranny of economic arrangements, but suggest that political and civil institutions (media corporations, schools, sports, et al.) also enact the garnering of white male position. In order to observe some of the complexities of this part of the hegemony, we need to look at some key 'representational politics' of the culture. To do this I return to my opening vignette from James Baldwin, the basic dynamics of which are also present in cultural representations like *A Bonfire of the Vanities*.

Monster-making and monster-slaying

The basic dynamic crucial to the two structural evils of sexism and racism is a dialectic between monster-making and monster-slaying, i.e. a process of making the other monstrous to a determinate point where that process also becomes a life-depriving one. This dialectic usually begins in the white mind with an exaggeration of the 'otherness' of African American peoples or of women. The other can certainly be celebrated as 'other', but in this dialectic there is a kind of accenting of the other that moves the perceiver, here the white male perceiver, from otherness to strangeness, from 'the other' to exoticized or wild creature.

I believe that the literature is increasingly showing that this cultural psychology is operative. In the imagination of Baldwin's white sheriff, woman is not just other but also an other who is either exoticized or threatening. To the white sheriff, the black woman as object of his sexual drive is a 'distant excitement', 'a far-away light'. The 'image of a black girl', according to Baldwin's portrait, creates a kind of excitement that is 'more like pain'.[11] The woman as focus of male passion here is a distant, provocative, exciting, but pain-producing creature. She becomes a monster.

The same is true of the white woman, Grace, although her monstrous otherness is not quite so obvious in the sheriff's imaginative vision. In the presence of Grace, he lies 'silent, angry, helpless'. Throughout the story, she is depicted as an other who is both 'sleeping giant' and 'frail sanctuary'. She is groggy and sleepy while he frustratingly tries to mobilize his sexual desire. But even in her non-threatening sleepy state, she is somehow threatening enough that he 'could not ask her to do just a little thing for him, just to help him out, just for a little while. . . .'[12] To the white sheriff, his white wife has a certain enormity for him as a 'sanctuary' in which he would like to bury himself like a child, but she is unresponsive. And as the sense of her as sanctuary mixes with her unapproachability, she becomes a monstrous other.

The monster-making is also evident in the white sheriff's imaginative vision towards black people – both men and women. That 'the image of a black girl' prompted excitement was not just due to her being woman; it was due also to her being black other. In fact, when Baldwin depicts the sheriff as thinking about 'nigger girl', he shows the sheriff steeped in the psychology of domination. Black woman is, unlike his wife, suggests Baldwin, someone 'he could ask . . . to do it'. She is commandable; she is one over whom he can more intensely feel power. Most notably, this

enables the injection of a pain-consciousness into his drive for pleasure. Her pain, as one who can be dominated, stimulates him, and the felt pain borne of a dominative relation helps to arouse his pleasure.

The importance of pain, as provoked by the image of Blacks as dominated others, is more blatantly played out in the sheriff's childhood memories of the torture and lynching of black males. As Baldwin allows us to explore the sheriff's sinister white supremacist mind, we see how there is a monster-making tendency at work in the white mind. The sheriff displays the stereotypes of the black male: as threat to 'his' white woman, as always having enormous genitalia, as 'gleaming body', as 'most beautiful object'.

What is horrific about these stereotyped forms of monster-making is that they all lead easily into some kind of slaying. Precisely here is the destructive dialectic. The black males as gleaming and most beautiful object become a '*hanging* and gleaming body', and 'the most beautiful *and terrible* object' he had ever seen.'[13] Historically, the slaying through lynching, castrating and burning, all done in a spirit of holiday ritual, followed inexorably from the imaginations of whites that had first made monstrous the black male.[14]

Black women and white women have also been exposed to the dynamics of slaying. Black women, for example, were also exposed to the threat and reality of lynching in addition to rape.[15] As the sheriff's mind illustrates, most usually black women were kept at a position in the white cultural-political world where they were viewed only as an available stimulus, without respect or power. Further, the white women as depicted by Grace also remains in the white mind as a slain figure. She remains a sleeping, unresponsive giant, a 'fragile sanctuary' to be protected pitifully but occasionally to be rustled out of her sleep 'to be done to' when, as with the sheriff, pain-full childhood memories (of lynching black men) arouse him to sex:

> Something bubbled up in him, his nature again returned to him . . . 'Come on sugar, I'm going to do you like a nigger, just like a nigger. Come on, sugar, and love me just like you'd love a nigger.'[16]

I am suggesting that it is this dialectic of monster-making and monster-slaying which in the white sheriff's mind unites his sexism and his white supremacism in one death-dealing complex. I am also suggesting that this dialectic, seen in Baldwin's white sheriff, is also often present in the representational politics of the current cultural hegemony. It is evident,

for example, in many cinematic portraits of women and blacks, as in *A Bonfire of Vanities* which I summarized briefly above.[17] This dynamic can be looked for in a host of the culture's representations, and in them we see a politics, represented in images, that functions as in the mind of Baldwin's white sheriff.

If we recall that these powerful hegemonic forces often even elicit a consent from victims as well as oppressors which makes oppression often seem banal or even natural, then it need not surprise us that a white male's senses of being a man, having 'masculinity', is tied up with this having a psychology of monster-making and monster-slaying towards women and people of colour. Within a sexist and racist cultural hegemony, then, refusing to make and slay women and blacks would almost be tantamount to, in the words of John Stoltenberg's book title, 'refusing to be a man'.[18] What kind of ecclesial practice might be sufficient as response to this monstrous problematic?

III Ecclesial practice: a dance of emancipative beasts

Because these dynamics of racist/sexist hegemony are buried so deeply in the psyches of many minds, disseminated so pervasively throughout the culture, and projected so subtly that they often evoke consent in the subordinated themselves – because of all this, moral outrage and opposition alone will not suffice. To use Gramsci's language again, a 'frontal attack' is not the best resistance. What is needed is a multi-faceted and more subtle but for all that more effective response.

A merely oppositional ecclesial practice might begin with its Christian commitment to full freedom for all peoples and then simply try to refuse making monsters of women and people of colour, and then try not to slay them. The trouble with such an oppositional stance is two-fold. First, it overlooks the fact that the church has often already been involved in making women and blacks 'monstrous' and then in slaying them. Women, in both Jewish and Christian traditions, begin to be seen as monstrous simply when depicted as 'other' to a God who is conceived in male terms, and then were often cast as possessing inordinately 'tempting sexuality', unrestrained desire, staining blood, etc. They were thus made monstrous, evoking strategies of control and containment, and being shut out from both life-giving ministries and life-protecting opportunities. Similarly, blacks, for example, in Christian and Western art, have regularly been imagined as devils; these 'devils' were often depicted with negroid

features. This was often a prelude to the subjecting of black peoples to a doom reserved for devils.[19] No, there can be no simple posing of righteous Christian tradition against sexism and racism.

Second, the oppositional stance, which might lead to a 'frontal attack', overlooks the ways the oppressive forces are etched into our identities as individual persons (as masculine, as feminine, etc.), *and* into our habitual modes of interaction collectively. Our very senses of masculinity, for example, are difficult to disentangle from the oppressive dialectic I have presented as variously working at the heart of sexism and white supremacism. To put the problem acutely from my own socio-personal location: is it possible to 'be a man against sexism and racism' when my being a man is so often socially and psychologically constructed by a distorting sexist and racist hegemony? This question can provoke despair and inaction; but it need not. Once asked, as it inevitably must be, I think, then we are prompted to construct a more supple and powerful mode of resistance to the hegemony.

As a kind of dance of resistance, I will present three strategic dimensions of ecclesial practice that we as Christians do well to develop. I will try to clarify each dimension, and offer implications for specific Christian practice and then for theological reflection. The three strategic practices I propose involve *absorbing*, *contesting* and *revisioning* elements of the hegemony. I do not suggest that Christian practice should enslave itself to any ordering of these. They are, rather, dimensions that overlap at times, can be taken in different sequences, played out in different keys. These practices are the basic material for the church's improvising of emancipatory praxis.

Absorbing

The monster-making and monster-slaying dialectic at the heart of sexism and racism in the hegemony requires, first, a strategy of absorption.[20] By this I mean that a Christian community resisting sexism and racism, as I have sketched it above, will have to see those distortions as operative in its own communal life.

Such 'absorption' means, first, *identifying* the presence of these systematic distortions within Christian and perhaps all resisting communities. Identifying as a strategy of absorption will probably lead not just to a pointing out of the problem, but also to a throughgoing examination of the patterning of sexism and racism in the ecclesial communities' life.

This strategy of absorption thus refers to something still more

troubling: a *depth acknowledgment*, i.e. a sobering realization that hegemonic forces are so powerful that it will hardly be possible to exorcize sexism and racism from our lives without excising, at least in feeling if not in fact, traits that seem essential to our being as persons in society. Certainly, as I as a white male have wrestled with these problems, and as I have talked with others in positions similar to mine, the journey of resistance continually deepens and broadens into further self-critique of my own life as well as into searches for more effective resistance to external structures of oppression. By self-critique, I am not referring here to retreats into easy guilt trips or shame rituals. I am, rather, pointing to the more significant and perhaps more sobering realization that white male being-in-the-world, and our identities as persons who have that way of being, are steeped in the kind of monster-making and monster-slaying propensities I have presented.

This realization can provide the church and its theologians with a kind of deep psychological and pervasive sociological dimension to its teachings on original sin. Whatever the church may teach about the goodness of creation and humanity, the challenges posed by hegemonically sustained sexism and racism make more significant the church's awareness of the pervasiveness of sin, of an 'original sin' perhaps best put by Schleiermacher as having a powerful 'corporate character', and as 'common to all': 'in each the work of all and in all the work of each'.[21]

'Absorbing' hegemonic sexism and racism will mean, first, an *identifying* of their presence in even resisting Christian communities, and second, a *depth acknowledgement* of their pervasive presence. There is no simple exorcising of these monsters, however much we should pray that these demons be bound.

Contesting

By a strategy of contesting the sexist and racist elements of hegemony, I move closer to traditional notions of prophetic critique and protest. But again, this cannot be simply oppositional denunciation. Better, I suggest, is a kind of contestation that creates a sense of critique and protest by presenting the stories and testimonies of the victims of sexism and white supremacism.

The church and its theologians exhibit this contesting when their stories break the silence about the numbers of women who are sustaining battery (one every eighteen seconds), who are slipping beneath the poverty line in the USA, whose health care is often not a priority, whose issues are often

seen as 'minority concerns', whose sacrificial labour and contributions to international economies are often not even considered or reported in economic analyses.[22]

This contesting also comes to the fore when churches' stories do not let their co-citizens forget the horrors worked by white supremacism in this country. Church communities do well always to recall the stories of James Baldwin, Richard Wright and other novelists and historians, who have preserved a record of lynching, burning, castrating, raping, and then blatant and subtle discrimination – in short, horrific and deeply-persisting pain that so many of us today do not wish to hear, but amid which suffering peoples have forged hope and new life. Unless these stories are told, as the church's strategy of contestation, the ecclesial community and often the wider society will work only on lesser problems.[23] Only a trivialization of the church's gospel will then flourish.

Critique and protest, or a strategy of contesting the hegemony, best emerge from an ecclesial community that offers these concrete stories of pain. These constitute a rhetoric of protest. Recall, however, that I am suggesting that this story-telling, this strategy of contestation, does not take place apart from the absorbing strategy mentioned above. This means that if we white males, for example, engage in telling the stories of those who have suffered, we are not recounting only an oppression borne by others, but also one partially created and sustained by us. Hence, stories of pain suffered by primary victims of hegemonic sexism and racism also become stories of pain for the whole community. Contestation through story-telling then becomes a powerful way to create solidarity among different sectors of the resisting community.

Revisioning

With the strategy of revisioning, the resistance of ecclesial practice within hegemony comes to its culmination. 'Revisioning' is the strategy whereby the church's emancipative impulses seek to set in motion a new 'representational politics', attempting to put in place, and ritually strengthen, powerful images and language that have political effect which counter the reigning sexist and racist hegemony. When dealing with the monsters of sexism and racism, how might Christian communities do this?

They do it, of course, through the reading, teaching and proclaiming of the Bible's vision, for example, of restored community, a 'new kingdom' of God wherein destructive monsters are graphically depicted, in some of the Hebrew prophets and in apocalyptic literature, as meeting their destruc-

tion or being tamed, transformed into communities of peaceful co-existence.

But revisioning amid the monsters of sexism and racism occurs not just through using these original biblical narratives, but also in the construction and presentation of new narratives and new languages depicting the taming and transformation of the monsters that menace us. I believe that church communities effective in resisting cultural hegemony will embrace these new narratives and languages wherever they may be found. They may emerge not only in the creative imagination and visions of contemporary Christians, but also in those of other religious adherents, as well as among artists, musicians and others who dream of communities where the monstrous dialectics of sexism and racism cease.

Crucial to this revisioning is not so much a monster-free utopia as a representational politics that subtly transforms the monsters into beasts whose dancing movements enable emancipation from monstrous evil. In closing, I shall briefly suggest how I mean this, first in connection with sexism and then in connection with white supremacism.

In sexism, the woman's otherness is, as I have suggested, interpreted as monstrously threatening. A monster-free utopian response would seek to reject all notions of the power of woman as other, perhaps reject all language of otherness as somehow oppressive. This is laudable as an attempt to move behind or beneath often projected sexist fears in order to recover a sense of common humanity between the genders. But it overlooks the capacity of images of 'monstrous woman' to persist in the psychology and sociology of male-centred hegemony. It is necessary, therefore, to own the power of woman as other in the hegemonic collective psychology, seeking to realign that power with a current of emancipatory release for women, instead of with the currents that render woman's power in the form of a threat that then calls for or allows systems of death to slay the woman as other.

In an earlier work, I referred to the power of Christ in emancipatory community as that of a 'rough beast'.[24] This was a way of referring to the jarring, awesome, perhaps sometimes fear-provoking quality of Christ's healing, which yet meets us concretely in the world to restore humanity and creation to its full potential. Similarly, a Christian practice that resists the monster-making tendencies of culture towards women need not run completely from the 'beastly' power of women as other, the capacity of woman to be, amid and perhaps through her otherness, awesome, jarring, fear-provoking, but finally, for all that, an event of human and creative healing.

This kind of event often emerges in the church's representational politics when it uses female-specific imagery for God and sacral power. I am not defending, of course, any non-analogical identity of this imagery with God. Nor do I think this imagery alone is ever adequate. But the imagery does allow the ultimacy of power and love, traditionally associated with God-language, to meet us in woman-form, and it allows women and their representation to participate in sacrality. Male-centred hegemony moves so strongly against female-specific imagery for God *not* just because female images are in opposition to male-specific imagery, but in fact because female-specific imagery shares something in common with male-specific imagery, i.e. the capacity to tap into the powerful currents of gender representation wherein lie possibilities for both monstrous horror and positive beastly transformation. Ecclesial communities do well, then, to dance out the whole experiment of female imagery for the sacred in relation to the full range of concerns in creation and human community.

In white supremacism, too, the oppressive dialectic often means seizing on ethnic or skin-colour otherness, making it monstrous and then having a threat that hegemonic whites feel compelled to quash. Further, as with sexism, it is tempting to have done with the whole notion of monstrous 'other', and use only a language of 'common humanity' that sees these differences as secondary or 'accidental'. But this strategy alone will not exorcize the monster of racism.[25]

Once again, I believe that a representational politics that revisions the power of 'Black' peoples as other, or African-Americans as culturally other, will have to value these modes of otherness, as well as critique exploitative dialectics of otherness. True, we all may pray for a day and society that is colour-blind and free of a fragmenting culture-consciousness, but the collective conscious (and *un*conscious) of colour and culture will not go away that easily. They are too yoked to deep and socially-reinforced monstrous forces. The church does well, then, to tap into those forces, acknowledging again a 'beastly' transformative power in Blacks *as* black, in African-Americans *as* African-Americans, or *as* African. Hence, as beastly and at times as threatening to whites as it may seem, blackness (black bodies, blackness of the galaxy, black history, struggle and hope) needs to be represented by the church as beautiful disclosure, as transforming grace. Further, as Joel Kovel has suggested, we whites and all peoples need to welcome our own unknown darkness, our own rich blackness.[26]

We need still what Gayraud Wilmore long ago termed a 'blackenization' of the church and its language, which sacrally revalues what has long been descecrated by many ecclesial and cultural hegemonies.[27] The presence of God in the night, the sacral luminosity of darkness,[28] the fullness of colour in the range of blackness, the beckoning promise that all colours and ethnicities of people can sense in the beauty of black – here, in all this, is a possibility for a new representational politics.[29] Further, it is a representational politics that can also tap into some biblical vision:

> If I say, Surely the darkness shall cover me
> Even the night shall be light about me . . .
> The darkness and the light are both alike to Thee.[30]

Again, this 'blackenization' is no mere opposite to the rhetorics that value whiteness. It is, though, a kind of counterpart to that rhetoric which joins with it also to tap into the deep and pervasive power of colour to code our deepest fears and evoke our profoundest awe, at least in the context of US cultural history where colour obsession has been engrained. The church's revisioning representational politics needs to tap these currents, thus directing the hegemonic monsters into a new, creative dance of beasts who empower emancipation for us all. It is this kind of representational politics that subtly but powerfully resists and undermines the powerful dialectic of monster-making/monster-slaying so depicted in Baldwin's writing and elsewhere as at the heart of masculinist and white supremacist hegomonic practice.

So it is that perhaps a poem, like Margaret Walker's 'THIS IS MY CENTURY . . . Black Synthesis of Time', which begins with the address of 'O Man', is not only a promise to her own African-American peoples but also a challenge to all humanity to find its place in a Black synthesis. Perhaps the 'O Man' can even be heard as challenge to white male-man finally to find our liberating place – as one finite part of the whole – in the sacral luminosity of the 'black and beauteous gods' and 'against one darkened sky'. Thus:

> O Man, behold your destiny.
> Look on this life
> and know our future living;
> our former lives from these our present days
> now melded into one.

Queens of the Nile,
Gods of our Genesis,
Parade of centuries
behold the rising sun.
The dying Western sky
with yawning gates of death,
from decadence and dissonance
destroying false and fair;
worlds of our galaxies,
our waning moons and suns
look on this living hell
and see the rising sun.

This is my century
I saw it grow
from darkness into dawn.
I watched the molten lava pour
from red volcanic skies;
Islands and Mountains heave
into the Sea
Move Man into the spiraled axis turn
and saw six suns and sunsets rise and burn.

Osiris, Isis, black and beauteous gods,
whence come your spectacle
of rhymed life and death?
You gods of love
on pyres of sacrifice
our human hearts become
old hearthstones of our tribal birth and flame:
the hammer and the forge,
the anvil and the fire,
the righteous sparks go wild
like rockets in the sky.
The fireworks overhead
flame red and blue and gold
against one darkened sky.
O living man behold
your destined hands control
the flowered earth ablaze,
alive, each golden flower unfold.

Now see our marching dead
The tyrants too, have fled.
The broken bones and blood
Have melted in the flood.[31]

Notes

1. James Baldwin, 'Going to Meet the Man', in *Going to Meet the Man*, New York 1948, 198–218.

2. For one example from this literature, which also factors in economic exploitation, see Nancy C. M. Hartsock's study, *Money, Sex and Power: Toward a Feminist Historical Materialism*, Baltimore, MD 1983.

3. Antonio Gramsci, *Selections from the Prison Notebooks*, ed. and trans Quentin Hoare and Geoffrey Nowell Smith, New York 1974. An excellent secondary source summary of Gramsci is T. J. Jackson Lears, 'The Concept of Cultural Hegemony: Problems and Possibilities', *The American Historical Review* 90.3, 1985, 567–93.

4. Cathy Schwichtenberg, *The Madonna Connection: Representational Politics, Subcultural Identities, and Cultural Theory*, Boulder 1993, 2.

5. Ibid., 3ff.

6. On the essential connections between Christian communal practice and emancipation or freedom, see Peter C. Hodgson, *God in History: Shapes of Freedom*, Nashville, TN 1989, ch. V; and Mark Kline Taylor, *Remembering Esperanza: A Cultural-Political Theology for North American Praxis*, Maryknoll, NY 1990, ch. 5.

7. Dante Germino, *Antonio Gramsci: Architect of a New Politics*, Baton Rouge 1990, 257.

8. On the necessity of using but criticizing metaphors for war in the process of Christian discipleship, see Walter Wink, *Engaging the Powers : Discernment and Resistance in a World of Domination*, Minneapolis, MN 1992, 308–14.

9. Indeed the whole notion of inside/outside is called into question by the notion of hegemony as I have developed it, and by the accompanying notion of emancipative resistance I propose.

10. Julianne Malveaux, 'Popular Culture and the Economics of Alienation', in Gina Dent (ed.), *Black Popular Culture: A Project by Michele Wallace*, Seattle, WA 1992, 200–8, esp. 203ff.

11. Baldwin, 198. 'Going to Meet the Man' (n. 1).

12. Ibid.

13. Ibid., 216.

14. For further study of this, see Trudier Harris, *Exorcising Blackness: Historical and Literary Lynching and Burning Rituals*, Bloomington 1984, 91–4.

15. On this as threat and sometimes enacted, see the memories of Carol Freeman as recorded in Studs Terkel, *Race: How Blacks and Whites Think and Feel about the American Obsession*, New York 1992, 34.

16. Baldwin, 'Going to Meet the Man', 217.

17. For a study of recent films in which this dialectic is operative, see Bell Hooks, 'Eating the Other', in *Black Looks: Race and Representation*, Boston 1992, 21–39. In

her rendering of the dialectic, Hooks speaks of fantasizing the 'primitiveness' of the black woman as other as part of an exploitation that reinforces her subordinate place in the *status quo*, thus, in my language, ensuring the dynamic of slaying.

18. John Stoltenberg, *Refusing to Be a Man: Essays on Sex and Justice*, New York 1990.

19. Jean Vercoutter, Jean Leclant, Frank M. Snowden, Jr and Jehan Desanges, *The Image of the Black in Western Art: I, From the Early Christian Era to the 'Age of Discovery'*, Foreword by Amadou-Mahter M'Bou, Director General of UNESCO, Cambridge, MA 1979, esp. 64ff. ('White God and Dark Devil').

20. I am taking this term from the work of Lynn Stephen, who uses it to refer to on aspect of resistance employed by Zapotec women in a hegemonic context that is not only patriarchal, but also racist (towards these native Mesoamericans of deep south Mexico) and economically exploitative. See Lynn Stephen, *Zapotec Women*, Austin, Texas 1991, 14–15.

21. F. D. E. Schleiermacher, *The Christian Faith*, ed. H. R. Mackintosh and J. S. Stewart, Edinburgh 1928, para. 71, 288.

22. For reports on the status of women, nationally and internationally, see Marilyn French, *The War Against Women*, New York 1992; and Marilyn Waring, 'The System of National Accounts, Or The Measure and Mis-Measure of Value and Production in Economic Theory', in Lenora Foerstel (ed.), *Women's Voices on the Pacific: The International Pacific Policy Congress*, Washington 1991, 63–78.

23. On the importance of telling these stories, for African-Americans themselves as well as others, see again Trudier Harris as cited above.

24. Taylor, *Remembering Esperanza* (n. 6), ch. 5.

25. My argument here should not be read as holding that a rhetoric of 'common humanity' is unncessary. By no means. But I do hold that it alone is insufficient, without some preservation of a rhetoric of otherness that taps into the sense of difference here, whether that difference pertains to gender, ethnicity or culture. On the necessity of difference to achieving liberation, see Iris Marion Young, *Justice and the Politics of Difference*, Princeton, NJ 1990.

26. Joel Kovel, *White Racism: A Psychohistory*, New York 1984.

27. Gayraud Wilmore, *Black and Presbyterian: The Heritage and the Hope*, Philadelphia 1983, 125.

28. Long ago, Howard Thurman inspired many of us to dream of 'the luminous darkness'. See Thurman, *The Luminous Darkness: A Personal Interpretation of the Anatomy of Segregation and the Ground of Hope*, New York 1965.

29. A similar attempt to revalue what often has been devalued seems to be at work in the movements among African-Americans to recover an Afro-centric perspective. The issues of Afrocentricity have been critically examined both within and without the movement, and some of the problems and possibilities encountered in that movement are similar to those encountered in movements to revalue blackness. For a womanist view on Afrocentricity, see Cheryl J. Sanders, 'Afrocentrism and Womanism in the Seminary', in *Christianity and Crisis*, 13 April 1992, 123–6.

30. Psalm 139.11–12.

31. From Margaret Walker, 'THIS IS MY CENTURY . . . Black Synthesis of Time', in Amiri Baraka (LeRoi Jones) and Amina Baraka (eds.), *Confirmation: An Anthology of African-American Women*, New York 1983, 361–3.

II · Violence against Women: Exploring Gender Construction

'Go and Suffer Oppression!' said God's Messenger to Hagar
Repression of Women in Biblical Texts

Irmgard Fischer

Phyllis Trible includes the story of the slave-girl Hagar (Gen. 16; 21) in her *Texts of Terror*. There is no denying it: in the biblical writings there are texts which legitimate social discrimination against women and sometimes even violence against women. From an early stage this problem has been a theme of feminist scholarship.[1]

1. Biblical texts with sexual violence against women as their theme

To the stories discussed by Phyllis Trible in her *Texts of Terror*, of the rape of the unnamed wife of the Levite (Judg. 19f.; with reference to the parallel Gen. 19, Lot's daughters) and Tamar (II Sam. 13), should be added the stories of Dinah (Gen. 34) and the abandonment of Sarah (Gen. 12.10ff.), the compulsion on Bathsheba to sleep with David (II Sam. 11), and the charge of adultery laid against Susanna (Dan. 13). The legal regulations about the rape of virgins (Ex. 22.15f.; Deut. 22.23ff.) should similarly be included among the 'texts of terror' because they treat the offence as a violation of the rights of the father or future husband and not as a crime against the woman. Acceptance of the possibility for the free Israelite full citizen to have intercourse with slave girls and (virgin) women taken as prisoners of war (Num. 31.18) must also be seen as the institutionalization of sexual violence against women by society.

All these narratives are concerned wtih violence against women, which runs the whole gamut of repression of women because they are women, from sexual denunciation (Dan. 13) through compulsion (Gen. 12.10ff.; II Sam. 11) to rape (Gen. 34; II Sam. 13) and sexual murder (Judg. 19).

The narratives adopt very different attitudes in evaluating cases: some of the violent actions are explicitly condemned on the basis of sensitivity to social laws (e.g. II Sam. 13); in other narratives God intervenes directly to rescue a woman from her oppression (e.g. Gen. 12.10ff.); in yet others God avenges the injustice later (e.g. II Sam. 11), but not always in such a way as to help the woman (Judg. 19).

In her hermeneutical approach, Elisabeth Schüssler Fiorenza points out that texts which do not explicitly condemn such violence cannot 'claim the authority of divine revelation', but are to be read as a memory of suffering in order to open up the perspective of hope for liberation as a dangerous, subversive recollection.[2]

Ancient Israelite society had a patriarchal constitution: in other words, a few males had power over all other socially inferior males, and over women and children.[3] Although we can learn from the texts of the First Testament about individual women who were very strong and also made their mark politically, women did not have the same rights and possibilities as free Israelite men. This social imbalance of the sexes must be taken into account in all the texts.

2. Androcentric law legitimates violence against women

Now there are also biblical texts which attempt to legitimate the harassment of women by divine authority. The so-called 'Jealousy Ordeal' in Numbers 5.11–31[4] may be taken as an example. The ordeal is introduced with the words, 'Yahweh spoke to Moses, saying: Speak to the Israelites and say to them . . .' Here the following instruction is clearly presented and authorized as proclamation of the will of the God of Israel.

In the genre of casuistic law, first the case is presented of an adulteress who was not caught in the act but whose husband is suspicious or simply jealous (5.12b–14a). At the same time, however, the possibility that the husband is unjustly accusing his wife is considered (v. 14b). To discover whether the woman is guilty or innocent, the husband is given the right to haul her before the priest. She must drink the water of bitterness, holy water with dust and the materialized curse (v. 23). The woman also has to say 'Amen, Amen', and thus bring down a conditional curse upon herself.

True, the conjuration of the priest (vv. 19f.) first mentions the possibility of innocence, and indicates that this will be demonstrated by the water of bitterness; however, far more words are devoted to the possibility of guilt: the woman becomes the proverbial curse. The possibility of innocence is considered second, in accordance with the casuistic law which is presented at the beginning: if the woman remains unscathed. Up to this point the casuistic law is strictly maintained: in each case there is a clear distinction between guilty and innocent, and in the words of the priest the assumption of innocence comes first. However, the final summary of this Torah on jealousy shows the problem: according to Old Testament law one would expect the punishment of a man who had unjustly accused his wife. But this principle, which serves as a deterrent against false accusations in sacral justice to guard against calumny (Deut. 19.16ff.; Dan. 13.61ff.), evidently does not apply to women who are denounced over sexual matters. Any husband who unjustly accuses his wife out of jealousy is free of guilt (5.31a)! But the wife is not free to subject herself to the procedure, while for the husband the call for the divine judgment is completely without risk.

Here it is evident that divine law and the divine verdict are one-sidedly commandeered by and for males. As in the narrative texts the theme of which is violence against women, the inequality of the sexes is evident here. Such texts must be clearly recognized as androcentric by preaching and exegesis which seeks to speak to our day.

3. The legitimation of the oppression of women in the process of theologizing by means of biblical texts

It is essentially more difficult to deal with biblical texts which in their original form were composed as texts about the liberation of women, but have been reinterpreted repressively. As an example of how stories of liberation can become stories about oppression, I shall comment here on the two stories of the expulsion of Hagar and her child, Gen. 16 and 21.8–21.

As I mentioned at the beginning, Phyllis Trible treats these two texts as 'texts of terror', since God legitimates the oppressive action of the patriarchal couple Abraham and Sarah. Trible considers the two narratives exclusively in their final form; if we do not investigate the literary growth of the text and only begin from the final form, we can agree with this finding.

However, the two narratives are not all of a piece, and in both cases one must voice a suspicion that the passages which legitimate the violence against Hagar were only inserted at a later stage.

The first parts of the two narratives which recount the separation of Hagar from the patriarchal couple are stories about the oppression of Hagar, who has no social rights, in the house of her master and mistress. However, in each case the second part takes place in the wilderness and recounts the encounter of Hagar with a messenger of God who imparts a message of salvation for her future. In the final text what we have here is an explanation, which is narrated twice, of why Hagar and her son Ishmael live apart from the patriarchal couple and Isaac is thus the only legitimate heir and vehicle of the promise.

Hagar's flight: Genesis 16

We must think in terms of a three-stage process of growth in the case of Genesis 16.[5]

The basic narrative (Gen 16B) tells the story of a woman who has no freedom, who is used by her mistress as a solution to the latter's infertility, and when she refuses to give her consent, is sexually exploited. She is to bear for Sarah the child Sarah longs for. Sarah is thinking only of herself. What matters is *her* wish for a child, not an heir for Abraham (v. 2). However, the slave girl used as a means to an end is aware of her value within the family when she becomes pregnant. She is no longer prepared to accept the social structure of mistress and slave. Neither Sarah nor Abraham, who have initiated the triangular relationship, is capable of providing a constructive solution to the difficulties posed by this situation. Sarah does not have things out with Hagar, but avoids putting herself on the same level as Hagar. She discusses the matter with someone of her own kind, with Abraham. She accuses him on the grounds that his refusal to recognize the slave girl is violence against her (v. 5) and that he is causing this by his own passive role as an onlooker. Abraham reacts in a dismissive way. He evades the conflict by refusing any protection to Hagar, the woman who is bearing his child, and reminding Sarah of her high social position: 'Behold, your slave is in your hand, do to her as you please!' (v. 6). Sarah makes excessive use of the force granted the mistress by the patriarchal system, which legitimates not only the rule of the male over the female but also a social hierarchy. She so overdoes her authority over someone who is not free that this slave, aware of her position, flees from her harsh mistress. Thus the one who is oppressed herself puts and end to the

history of oppression. The pressure of suffering is evidently so great that Hagar takes upon herself the risks of the runaway slave, who was punished extremely severely in the ancient Near East (the only way in which the system of slavery could survive). Hagar flees into the wilderness and rests by a spring.

The second part of the story begins with this change of place and situation (vv. 7–14); in Gen 16B it is a tale of liberation. YHWH's messenger meets Hagar by the spring, addresses her by name (for the first time in Gen. 16!), and asks her where she has come from and where she is going. Hagar replies truthfully to the question where she has come from: she is the slave of Sarah, from whom she has escaped. She herself cannot answer the question where she is going, but God's messenger can: beginning with her pregnant state, he promises her that she shall bear a son and that he will be free, indeed will even be able to prevail against his brothers. In Gen 16B the God of the patriarchal couple thus acts against their will and against the hierarchical-social subjection of the slave to the mistress. He endorses the revolutionary act of flight from slavery! So the original narrative Gen 16B is a story of liberation. YHWH sets himself against his elect when these are oppressive; he puts himself on the side of those to whom violence is done.

A revision (= Gen 16R, probably from the hand that put Gen. 21 in its present context)) now adds vv. 9, 10, a command to return and a promise, despite the fact that these make the divine messenger's words to the slave girl (16.11f.) anachronistic. However, the divine messenger does not follow general legal practice in the ancient Near East by sending the slave girl back to her mistress, but calls for her subjection to both mistress and master (16.9 plural; cf. 16.6, singular!). In this way not only is the order of maid and masters restored, making YHWH a God who sustains the system, but the oppression is explicitly legitimated and submission is called for. While the promise in v. 10 which is added later tones down somewhat the command to return, the divine pedagogy is one of the carrot and the whip. The story of liberation is made a story of oppression.

However, Genesis 16 is worked over yet once more. Verses 3, 15, 16 can be excised as the latest, Priestly part. P has Ishmael born in the house of the patriarchal couple (vv. 15f.).[6] Abraham recognizes him as a legitimate son (17.18ff.). So it is understandable that in P Sarah brings her slave girl Hagar to Abraham as a legitimate wife (*issa*, not concubine). Moreover in P Ishmael is never separated from his father – P has no account of any

separation. The story of Hagar is not told as a text of terror but rather as the story of an upwardly mobile woman: she is buried as the slave-girl wife of her master, to whom she bears the longed-for son who will maintain the tribe's existence.

The expulsion of Hagar and Ishmael, Genesis 21

The second story, about the separation of Hagar and her son from the patriarchal couple, is not a literary unit either. Verses 11–13 have been inserted into the original basic narrative (Gen 21B). The story loses nothing by their omission. Sarah's wish is sufficient reason for the command to Abraham to drive them out, and is only subsequently endowed with divine authority: the promise to Abraham for his son Ishmael in v. 13 is given to Hagar in almost the same words in v. 18, and is more in place there as a prospect of the future life of Ishmael, who has been rescued from death. The note about the continuation of the genealogy through Isaac serves to give a reason for the harsh command; the introductory comment that Abraham is displeased with his son attempts to put the patriarch in a better light.

The basic narrative has a similar structure to that of Gen 16B. Here too Sarah is the driving force. The cause of the conflict is not a dispute between women but rivalry between sons over their inheritance. Sarah's assertion that Ishmael will not share the inheritance with Isaac, her son, is a deliberate distortion of the legal situation: the son of a slave girl is only entitled to inherit if he is acknowledged as a son. If Ishmael is not recognized by his father, then the question of inheritance just does not arise. But if he is, he is Abraham's firstborn, and as second son Isaac inherits only with him, in a lower, second place.

Sarah's words are again egocentric (cf. 16.2). She does not speak of their son, but only of *her* son. And again Abraham unquestioningly obeys Sarah's instructions by doing what she wants. He sends his firstborn and the child's mother into the wilderness with barely a day's rations. In Gen. 21 Hagar does not leave her master's house by her own decision, but is driven out against her will. Whereas the resolute woman in Gen. 16 finds a spring by which she rests, in Gen. 21, as outcast she wanders around aimlessly in the wilderness. When the scant provision of water comes to an end, her son is in acute danger of death. She sits some way from him and weeps in despair. The picture of death painted by the narrator could hardly be darker. Hagar receives a saving oracle and God shows her the life-giving spring from which she can give her son something to drink. Sarah sees the

fulfilment of the promise given to the outcast for her son: God is with the boy until his adulthood.

So in its orignal form this version, too, is a story of the oppression, expulsion and dire need of a woman, though this is transformed into a story of salvation by the divine encounter. However, the revision makes it, too, a text of terror for women. The God who promises the father on the point of driving out his son that he also has a promise for him lets the boy get to the point of death.[7] Just as Abraham is merely concerned about his son, and not about the mother of his child (v. 11), so in vv. 12f. God does not mention the woman at all (v. 12f.). He approves the expulsion which first brings Hagar the deepest despair! In protecting the heirs of his promise from a rival, God endangers the life of the defenceless, the socially weak!

The revision of the texts turns the liberator God who in the basic narratives in Gen. 16 and 21 supports those who are deprived of their rights, oppressed and outcast, and who breaks open the structure of a slave-owning society, into one who preserves the system. He is now in fact the 'God of the fathers', who without reservation supports his elect. He legitimates their actions even when these are harsh and unjust.

In Gen 16R YHWH sanctions the superiority and subordination unquestioningly practised by the patriarchal system. Nor does he do this just by leaving it intact as a social fact, but rather by deliberately affirming it. The reviser could have achieved his aim of making Ishmael come into the world in the house of the patriarchal couple by a simple command to return. The express instruction to submit to even harsher oppression is an addition made from a theological perspective which so over-emphasizes the connection with God's elect that the ethical imperative 'Remember that you were a slave' is totally obscured.

In Genesis 21 it is probable that in connection with the sacrifice of Isaac in Gen. 22 we have a working out of the experience derived from the exile that God does not preserve people from catastrophe but rescues them in it. However, there is an essential difference between the two narratives, parallel in structure, of the 'sacrifice' of the two sons of Abraham, both of whom are rescued in extreme distress only by heavenly intervention: in Gen. 21 the parent who goes along with the child threatened by death does not go willingly. Hagar does not decide, like Abraham, of her own accord to obey a divine command. The expulsion is forced on her. If Gen. 21 is read without its context, Genesis 22, the story is a text which legitimates the expulsion of women and children without giving them provisions, in 'sacred' trust that God will take care of them.

Although it is not the prime concern of the revisions to approve of terror against women, the history of the tradition or the rewriting of these two biblical narratives nevertheless documents the ongoing temptation of an androcentric theology to set down its interests and social structures in the name of God. The process of theologizing which is always necessary for an adequate proclamation has to take up contemporary questions, but then always loses its innocence if for the sake of answering these questions it prescribes and legitimates injustice for socially weak groups. From biblical times to the present day it is predominantly women and children who become victims of such a (pseudo-)theological 'terror'.

One central statement about the nature of the God of Israel is the characterization of him as an advocate of widows and orphans and those who have no helper (Ps. 146.9; cf. Deut. 10.18). The confession by Israel of a God who welcomes the socially weak and those without rights is at the same time bound up with the confession that this God avenges transgressions against the rights of the poor and the oppressed. YHWH is a God of liberation from the house of slavery. So in Israel there must be no oppression (cf. Deut. 15.15). Thus all the texts of the Bible have to be measured by this central theologoumenon of Israel. That also includes those which in developing ever so urgent theological concerns think that they can reinterpret YHWH's option for the poor or make it secondary.

Notes

1. Cf. also P. Trible, *God and the Rhetoric of Sexuality*, Philadelphia 1978 reissued London 1992.

2. E. Schüssler Fiorenza, *Brot statt Steine*, Fribourg 1988, 55f.

3. For this definition of the patriarchate see E. Schüssler Fiorenza, *In Memory of Her*, New York and London 1983, 78.

4. In literary terms the text is not perhaps a genuine unit; cf. P. J. Budd, *Numbers*, Waco, TX 1984, 62–7.

5. For the following demarcation and exegesis see my Habilitationsschrift, *Untersuchungen zur theologischen Relevanz der Frauentexte in den Erzeltern-Erzählungen*, Graz 1993 (forthcoming 1994).

6. The insertion of P in Gen. 16 thus presupposes the command to return (= Gen 16R).

7. Scholars take virtually no heed of the consequences of the insertion of the divine discourse for the image of God which results!

Ecclesiastical Violence: Witches and Heretics

E. Ann Matter

In the Middle Ages and the early modern period, Christian women faced a dilemma of self-knowledge and self-definition. On the one hand, women had been identified since early Christian times as the origin of sin in the world and, consequently, a source of heretical ideas. On the other hand, an idealization of the female, especially evident in the growth of the cult of the Virgin Mary, ascribed to the abstract category 'woman' a variety of spiritual powers much at odds with the idea of women as the source of evil. Ecclesiastical violence against women was born in this deadly ambivalence.[1] Since Christian doctrine teaches that the incarnation of God was made possible through the body of a woman, the ambivalence manifested itself in increasing control of women's minds and bodies, and resulted in punitive strictures on both psychic and physical levels.

The history of women's monasticism in Western Christianity is a good venue for an analysis of this double-barrelled approach to women by the ecclesiastical hierarchy. As early as the turn of the fourth century, women in religious life were urged by their male religious mentors to think of themselves as 'brides of Christ'. Jerome's famous letter to Eustochium (*Epistle 22*) describes female ascetic chastity as a sacred marriage, invoking the love-language of the Song of Songs over twenty times.[2] As women's monasticism became an established mediaeval institution, a concern for strict enclosure of nuns was articulated with increasing clarity. To some extent, cloistering of nuns was thought necessary to protect women (and especially the 'brides of Christ') in a world in which women had no means to protect themselves. But it is also clear, as early as the sixth-century monastic rule for women written by Caesarius, Bishop of Arles, that there

was a connection between the assumption that women are responsible for sin in the world and the strict control of religious women by the ecclesiastical hierarchy.[3] This pattern is repeated in the sixteenth century, when the rulings of the last session of the Council of Trent decreed that all women's religious communities must be kept under strict enclosure.[4]

Women's minds were not, however, enclosed as easily as their bodies. One irony of the history of women's monasticism is the fact that some women found the cloister a rich ground for creative expression. Although it cannot be denied that some women entered religious life unwillingly, as political pawns of their families, many others chose the cloister to take advantage of the opportunity for autonomy and intellectual life available to women nowhere else. In a very real sense mediaeval women were, as Penelope Johnson puts it, 'equal in monastic profession' to mediaeval men.[5] Women's daily activities in the cloister may have been strictly controlled by the ecclesiastical hierarchy, but their spiritual and intellectual creativity enjoyed a free range which may be surprising and even shocking to modern sensibilities. We know, for example, that from the tenth century to the seventeenth women wrote and presented plays behind cloister walls.[6] There seems to have been as lively a tradition of musical composition and performance by nuns in the early modern period.[7]

But it was in the realm of spiritual creativity that mediaeval and early modern nuns became best known, where they were seen as at once more powerful and more dangerous. Mediaeval and early modern religious women were famous in their own day for their visionary and mystical writings, spiritual counsel and religious autobiographies. This body of Christian literature, neglected by scholars for centuries, has recently been made available to a wide reading public, and has become an important part of a revaluation of the master plot of Christian history.[8] Whereas women once were seen as peripheral to the story, at least until the emergence of the 'witch phenomenon' in the later Middle Ages, it is now understood that many powerful women were held up as recipients of a special type of grace of the divine presence which was granted far less frequently to men. The complex relationship between these visionary women and the male hierarchy who both controlled and venerated them established the pattern for ecclesiastical violence against women.

Two documents from the late fifteenth and the very early sixteenth centuries will illustrate this claim. The first text, the famous *Malleus maleficarum*, published by Heinrich Krämer and Jacob Sprenger, two inquisitors of the Dominican order, vilifies women as the cause of all men's

woes.[9] The title of this book, literaly 'The Hammer of (Female) Evil-Doers', is often translated as 'The Hammer of Witches', indeed, the pursuit, capture and destruction of witches (by definition, female witches) is its obsessive theme. Many of the most extravagant, outrageous claims of the *Malleus* have been quoted by feminist authors who argue that ecclesiastical violence against women derives from an assumption of female inferiority linked to an assessment of women as naturally carnal.[10]

Certainly, the authors of the *Malleus* show a puerile obsession with women's sexual powers, elaborated in the chapters devoted to lascivious descriptions of intercourse between witches and the devil, and in the truly amazing accounts of witches who, through intercourse, deprive men of their sexual organs.[11] As the most quoted phrase of the *Malleus* puts it: 'all witchcraft comes from carnal lust, which is in women insatiable'.[12] Yet an overly-literal interpretation of this type of material, such as Rosemary Ruether's suggestion that 'the very word *fe-minus* was construed as meaning "lacking in faith"',[13] misjudges the chilling depth of this accusation against women. Even the *Malleus* makes it clear that the power of women for evil is inherently possible because of women's greater power for good. Musing on the question 'Why Superstition is chiefly found in Women', the *Malleus* explains:

> For some learned men propound this reason: that there are three things in nature, the Tongue, an Ecclesiastic, and a Woman, which know no moderation in goodness or vice; and when they exceed the bounds of their condition they reach the greatest heights and the lowest depths of goodness and vice. When they are governed by a good spirit, they are most excellent in virtue; but when they are governed by an evil spirit, they indulge the worst possible vices.[14]

Given the zeal with which the *Malleus maleficarum* elaborates on the theme of female vice, it is understandably easy to ignore the claims of this passage for women's goodness and virtue. Yet it is striking that women and ecclesiastics are lumped together here, for even this is an acquiescence to a special type of spiritual power available categorically to women, but only to spiritually advanced men. In fact, the idea that women are the recipients of special spiritual powers is found in other writings of the age, outside the prurient context of this inquisitorial document.

A striking example is the testimony of Ercole d'Este ('Ercole il Magnifico'), Duke of Ferrara, about the political visionary Lucia Brocadelli da Narni. Lucia, a Dominican tertiary in Viterbo famous for her

reception of mystical visions and of the stigmata, was brought to Ferrara by Ercole in 1499, a prize possession he had sought for several years and obtained only by trickery.[15] Lucia was set up as the head of a new house of Dominican tertiaries in Ferrara, but her most important job was to advise Ercole on matters of state; she was one of the many 'pious counsellors of princes' of early modern Italy.[16] Ercole's satisfaction with her advice is reflected in two letters he wrote about Lucia which were printed together, in Latin and German versions, in 1501, where he argues that all Christian princes should have female spiritual counsellors to guide them. In the case of Lucia, Ercole professes special faith in her guidance because of the fact that she bore the stigmata, explaining that 'these things are shown by the Supreme Craftsman in the bodies of His (female) servants to conform and strengthen our Faith, and to remove the incredulity of impious men and hard of heart'.[17]

But, even though Lucia Brocadelli is an example of the real spiritual power exercised by religious women, her story also shows the limits of this power. Upon the death of Ercole, Lucia's status changed dramatically. The new Duke, Alfonso I, immediately banished her from court and revoked the privileges that had been granted to her house. At the tender age of twenty-eight, Lucia was a spiritual and political has-been; for the next four decades of her life, until her death in 1544, she was virtually a prisoner in her monastery. Lucia Brocadelli's life thus illustrates both a belief that women are invested with power, and the deep ambivalence of the male hierarchy towards this power.

Similar stories abound in Christian history. One of the most obvious (indeed, infamous) confirming examples is the career of Joan of Arc. The Maid of Orléans was obviously taken seriously and granted spiritual and political authority when it suited the rulers of church and state; and just as obviously abandoned, slandered and tortured when her usefulness was less apparent. As has been noted by recent scholarship, Joan's sudden rise to fame was possible because her actions were interpreted in the context of female religious prophecy.[18] Compared to the fate of Joan of Arc, who was burned at the stake as a heretic in 1431, the ecclesiastical violence suffered by Lucia Brocadelli was slight. Nevertheless, both women were victims of a culture of deep ambivalence wherein, to paraphrase Adrienne Rich, their wounds came from the same source as their power.[19]

The subtlety with which mediaeval and early modern Christian women recognied this ambivalence and used it for their own empowerment is one of the more complicated aspects of the history of ecclesiastical violence.

Hildegard of Bingen, the twelfth-century visionary and polymath known as 'The Sibyl of the Rhine', was particularly articulate about what Barbara Newman has called 'the divine power made perfect in weakness', that gave women a type of authority out of their very limitations.[20] As Hildegard wrote to the monks of Eberbach:

> But I – a poor woman, weak and frail from my infancy – have been compelled in a true and mysterious vision to write this letter. And lying in bed with a serious illness, I have written it by the command and assistance of God to present it to the prelates and masters who are sealed for God's service, that in it they might see who and what they are . . . And I heard a voice from heaven saying: Let no one despise these words, lest if anyone despise them, the vengeance of God fall upon him.[21]

.Three themes vie for prominence in this passage: the assumption of women's weakness, the certainty of God's revelation, and the warning to those who might doubt Hildegard's specific powers. The coexistence of these strands make possible the weaving of a strategy of survival in a climate of repression. Hildegard's claim for direct knowledge of God's will, couched in a protestation of weakness, is paralleled by the experience of other religious women of the Middle Ages and early modern period: Elisabeth of Schönau, for example, became a source and conduit of divine revelation for her brother Ekbert.[22] More complex is the relationship of Catherine of Siena and her confessor/amanuensis Raymond of Capua; in this case, Raymond not only reflected the inspiration of the woman in his spiritual care, but actually stressed the aspects of her experience that resonated most closely with his own, to a large extent creating the Catherine passed on to posterity.[23]

Lucia Brocadelli da Narni, Joan of Arc, Hildegard of Bingen, Elisabeth of Schönau, Catherine of Siena, were all exceptional women, famous in their own day, and vindicated by posterity. Joan, who suffered most from the violence of the church towards women, was canonized in the twentieth century; Lucia Brocadelli was officially beatified in the eighteenth century; Hildegard, Elisabeth and Catherine are finally being taken seriously by historians of Christianity. It is harder for us to reconstruct the ecclesiastical violence endured by women who did not become enshrined in the historical record of official Christianity. Na Prous Boneta is only one the many Cathars (male and female) destroyed by the Inquisition of the fourteenth century; like Joan of Arc, Na Prous's voice survives only in inquisitorial records.[24] But who were the 'begghini combusti', the burned

Beguines, to whom she compares herself? How many women were killed in the fervour of witchcraft persecutions between the fourteenth and the eighteenth centuries? Even this question has been politicized: 'only 100,000', say those who wish to protect Christianity from its own worst characteristics; 'nine million', answer those who find satisfaction in comparative genocide studies.[25] The search for statistics, like the study of the exceptions, only shows us to what extent the violence of ambivalence has afflicted women in the Christian tradition.

The final irony of this ambivalence is its historical pervasiveness. Although ecclesiastical authors no longer assume, as did the mediaeval scholars and canon lawyers, that women are not in the image of God,[26] most statements by twentieth-century hieresiarchs of Roman Catholicism that deign to mention women theologians and spiritual authors do so only to condemn and dismiss 'radical feminism'. But the history of Christianity has shown us that women's spiritual insights have been far more influential than the hierarchy wants to admit. In 1310, the Inquisition burned a Beguine named Marguerite Porete, author of a book called *The Mirror of Simple Souls*. The book, nevertheless, circulated widely, for centuries, in Old French, Latin, Italian, and Middle English; it was attributed to other, orthodox mystics, or presented as anonymous. Only in 1965 did Romana Guarini publish a critical edition of the Old French text along with the proof that the author of this celebrated text was Marguerite, the woman condemned and executed for heresy.[27] Christian women's spiritual insights have, in spite of everything, sometimes, somehow, managed to survive ecclesiastical violence.

Notes

1. For general discussions of this ambivalence, see Frances Gies and Joseph Gies, 'Eve and Mary', in *Women in the Middle Ages*, New York 1980, 37–59; Mary Daly, 'The Pedestal Pushers', in *The Church and the Second Sex*, Boston 1968/1975/1985, 147–65.

2. Elizabeth A. Clark, 'Uses of the Song of Songs: Origen and the Later Latin Fathers', in *Ascetic Piety and Women's Faith: Essays on Late Antique Christianity*, Lewiston/Queenston 1986, 403–6, text ed. J. Hillberger, CSEL 54, 1, 1910, 143–211. See also Jo Ann McNamara, 'Muffled Voices: The Lives of Consecrated Women in the Fourth Century', in *Medieval Religious Women 1: Distant Echoes*, ed. John A. Nichols and Lillian Thomas Shank, Kalamazoo, MI 1984, 11–29.

3. Jane Tibbets Schulenberg, 'Strict Active Enclosure and its Effects on the Female Monastic Experience (500–1000)', in Nichols and Shanks, *Distant Echoes* (n. 2), 51–86.

4. Raymond Creytens, 'La riforma dei monasteri femminili', in *Il concilio di Trento e la riforma tridentina*, Rome 1963, 1:45–83; Katherine Gill, 'Open Monasteries for Women in Late Medieval and Early Modern Italy: Two Roman Examples', *The boy get to the Crannied Wall: Women, Religion and the Arts in Early Modern Europe*, ed. Craig Monson, Ann Arbor, MI 1992, 15–47.

5. Penelope D. Johnson, *Equal in Monastic Profession: Religious Women in Medieval France*, Chicago 1991.

6. For Hrosvit, a German author of the tenth century, see *The Plays of Hrotsvit of Gandersheim*, translated by Katharina Wilson, New York 1989, and Elizabeth Avilda Petroff, *Medieval Women's Visionary Literature*, New York 1986, 114–35; for Tuscan convent drama in the sixteenth and seventeenth centuries, see Beatrice del Sera, *Amor di Virtu, Commedia in cinque atti 1548*, edited by Elissa Weaver, Ravenna 1990; Elissa Weaver, 'Convent Comedy and the World: The Farces of Suor Annalena Odaldi (1572–1638)', *Annali d'Italianistica* 7, 1989, 182–92; and Elissa Weaver, 'The Convent Wall in Tuscan Convent Drama', in Monson, ed., *The Crannied Wall*, 1992, 73–86.

7. Robert Kendrick, 'The Traditions of Milanese Convent Music and the Sacred Dialogues of Chiara Margarita Cozzolani', in Monson (ed.) *The Crannied Wall*, 1992, 211–33; Craig Monson, 'Disembodied Voices: Music in the Nunneries of Bologna in the Midst of the Counter-Reformation', in Monson (ed.), *The Crannied Wall*, 1992, 191–209.

8. In English alone, collections of writings by medieval religious women include Peter Dronke, *Women Writers of the Middle Ages*, Cambridge 1984; Petroff, *Medieval Women's Visionary Literature*; Katharina M. Wilson, *Medieval Women Writers*, Athens, GA 1984; Emilie Zum Brunn and Georgette Epiney-Burgard, *Women Mystics in Medieval Europe*, New York 1989.

9. Heinrich Krämer and Jacob Sprenger, *Malleus maleficarum*, translated with introductions, bibliography and notes by Montague Summers, New York 1971.

10. Rosemary Radford Ruether, *New Woman New Earth: Sexist Ideologies and Human Liberation*, New York 1975, 19, 72, 97–8, 101–2; Rosemary Radford Ruether, *Sexism and God-Talk: Toward a Feminist Theology*, Boston 1983, 170.

11. *Malleus maleficarum*, Part II, Question 1, Chapter IV, ed. Summers, 109–14; Part II, Question 1, Chapter VII, ed. Summers, 118–22, including the famous account of the woman who kept a collection of stolen penises (the biggest one of which belonged to the village priest) in a nest in a tree, ed. Summers, 122.

12. *Malleus maleficarum* Part 1, Question 6, ed. Summers, 47.

13. Ruether, *New Woman New Earth*, quoting an unpublished paper by Barbara Yoshoika, 34, n. 21.

14. *Malleus maleficarum* Part 1, Question 6, ed. Summers, 42.

15. For the story of the smuggling of Lucia out of Viterbo in a laundry basket, see Serafino Razzi, *Vite dei santi e beati, cosi huomini come donne del sacro ordine de' frati predicatori*, Florence 1577, 151–7; P. F. G. Marcianese, *Vita della b. Lucia da Narni*, Viterbo 1663; the entry under Lucia Brocadelli's name in *Dizionario biografico degli Italiani*, Rome 1972; and Edmund G. Gardner, *Dukes and Poets in Ferrara: A Study in the Poetry, Religion and Politics of the Fifteenth and Early Sixteenth Centuries*, New York 1968, reprinted from the 1904 edition, 379–88.

16. Gabriella Zarri, 'Pietà e profezia alle corti Padane: le pie consigliere dei principi', in *Le sante vive: Cultura e religiosità femminile nella prima età moderna*, Turin 1990, 51–86; 'Le sante vive', in *Le sante vive*, 87–163.

17. Ercole's two letters about Lucia, dated 4 March 1500 and 23 January 1501, are printed in *Spirituallum personarum feminel sexus facta admiratione digna*, Nürnberg 1501, six unpaginated folia. This text is discussed by Gardner, 367.

18. Andre Vauchez, 'Jeanne d'Arc et la prophétisme feminin des xive et xve siècles', in *Jeanne d'Arc: une époque, un rayonnement*, Colloque d'histoire médiévale, Orléans 1979, 159–68; Francis Rapp, 'Jeanne d'Arc, témoin de la vie religeuse en France au xve siècle', in *Jeanne d'Arc*, 169–79; Deborah Fraioli, 'The Literary Image of Joan of Arc: Prior Influences', *Speculum* 56, 1981, 811–29.

19. 'Her wounds came from the same source as her power', Adrienne Rich, 'Power', in *The Dream of a Common Language: Poems 1974–1977*, New York 1978, 3.

20. Barbara Newman, 'Divine Power Made Perfect in Weakness: St Hildegard on the Frail Sex', in *Medieval Religious Women II: Peaceweavers*, ed. Lillian Thomas Shank and John A. Nichols, 'Kalamazoo, MI 1987, 103–22; Barbara Newman, 'The Woman and the Serpent', and 'The Daughters of Eve', in *Sister of Wisdom: St Hildegard's Theology of the Feminine*, Berkeley, Ca 1987, 42–120.

21. Hildegard, Epistle 51, PL 197: 268C, translated by Newman, 'Divine Power', 103.

22. Anne L. Clark, 'Conclusion: The Prophetic Voice of a Twelfth-Century Woman', *Elisabeth of Schönau: A Twelfth-Century Visionary*, Philadelphia 1992, 129–35.

23. Caroline Walker Bynum, *Holy Feast, Holy Fast: The Religious Significance of Food to Medieval Women*, Berkeley, Ca 1987, 166–80; Karen Scott, 'Saint Catherine of Siena, "Apostola"', *Church History* 61, 1992, 34–46.

24. Petroff, *Women Visionaries*, 276–7, 284–90.

25. Ruether, *New Woman New Earth*, 111 n. 1.

26. E. Ann Matter, 'Innocent III and the Keys to the Kingdom of Heaven', in *Women Priests: A Catholic Commentary on the Vatican Declaration*, edited by Leonard Swidler and Arlene Swidler, New York 1977, 145–51.

27. Romana Guarini, 'Il Movimento del Libero Spirito', *Archivio italiano per la storia della pietá* 4, 1965, 351–708; Petroff, 280–2, 294–8.

Maria Goretti: Rape and The Politics of Sainthood

Eileen J. Stenzel

Introduction

For years I taught an undergraduate course on Catholicism. The canonization of Maria Goretti in 1950 was included in an overview of Catholic attitudes and practices regarding women. Inevitably, students would end up in a heated debate. Some would claim that the rationale for Maria's canonization was understandable given the social climate of the 1950s. Others were outraged that the Roman Catholic church would ever have said that a woman is better dead than raped.

A feminist pastoral theology concerned with violence and the politics of sainthood addresses the problem these students shaped in their debate. On the one hand, it recognizes that ecclesial thought and practice must be understood within its many contexts. On the other hand, it offers criteria for evaluating these traditions.

The canonization of Maria Goretti (1890–1902) is compelling to feminist theologians because it is a pastoral-theological response to violence against women. Women, like men, are victims of random violence. However, there are forms of violence which are directed against women-as-women. Rape, battering and sexual harassment are examples of gender-based violence. They represent the epitome of all that is wrong about sexism and all efforts to portray it as normal. It is an awareness of women's increased vulnerability to violent attack within patriarchal systems that fuels the efforts of feminist scholars to assess critically how these systems find justification within our respective disciplines. Feminist theologians share this commitment to identify how patriarchal ecclesial

consciousness and praxis function to legitimate violence against women by supporting the conditions which cause it.

A feminist pastoral theology concerned with violence and the politics of sainthood must do four things: 1. identify a working understanding of women's experience of violence; 2. show how patriarchal norms have been incorporated into ecclesial pastoral traditions; 3. propose non-sexist alternatives to ecclesial self-understanding and praxis; and 4. submit those proposals to critical assessment.

Feminist consensus on violence against women

Prior to the development of feminist perspectives on rape in the late 1960s, societal definitions of rape excluded the victim's experience of rape and insisted that rape was a form of sexual deviance often precipitated by its victims.[1] Additionally, these definitions of rape presumed a woman's need for protection and limited that right of protection to those women who adhered to traditional female roles and behaviours.

Feminist scholars have viewed rape in the context of patriarchal culture and defined it in terms of victims' accounts of their experience of rape. Feminists have argued that the dominant-subordinate model of male-female relatedness is an inherently violent structure of relatedness. Patriarchal culture fosters a spectrum of behaviours including at its most violent end rape, battering and sexual harassment. In this context, women's experience of violence becomes a paradigm because it conveys basic assumptions about the reality of sexism.

While differences in interpretation of the paradigm continue, there is a growing consensus among feminist scholars about the cause and function of violence against women as women.[2] There is general agreement that violence against women rises from a systemic cultural acceptance of power and control as a means of affecting and defining human relationships.[3] Our very definitions of formal relationships carry the connotation of power-as-control: leaders and followers, adults and children, religious and lay, employers and workers, men and women, young and old, white and black, rich and poor.

The structure of power-as-dominance involves myths which function to legitimize the controlling behaviour of the dominant group. Structures of male dominance are supported by mythical stereotypes about women. Among these are: 1. the identification of women only in terms of sexuality and reproduction; 2. the assertion that women have a distinct nature that

best suits them to bear the greater burden of responsibility for sexual morality, nurturance and service; and 3. the assumption that aggression is the natural mode of male behaviour and submissiveness the natural mode of female behaviour, thereby defining female submission as consent.

Mythical assumptions about the relationship between men and women have been incorporated into legal, social, political and religious thought and practice. Prosecution of rape has required proof of excessive use of force because it has been assumed that some degree of force is normal in male-female sexual relatedness. In many countries women are unable to charge a man to whom they are legally married with rape because of assumptions about the conjugal rights of married men.

This model of male-female relatedness denies personal, social and moral autonomy to women. Denial of the right to self-determination and equal partnership with men are the conditions of subordination which increase the likelihood that a woman will be abused in her home, in her job, by a stranger and even in her church by those designated to wield power over her.

There is also general agreement about the function of gender-based violence. Studies of rapists and men acknowledged to be batterers suggest that the purpose of the violent behaviour was to assert dominance and/or to punish inappropriate female behaviour.[4] While interventions with offenders vary, there is general consensus on the goals of treatment. These are: 1. changing the offender's attitude towards women; 2. changing controlling behaviour; and 3. learning to deal with anger.

The context

To read the lives of the saints literally is to misunderstand the polemics and politics of sainthood. Ecclesial polemics about saints are shaped with a purpose in mind: to promote as moral one set of values and behaviours and to condemn others as immoral. Canonization is, by its nature, political. What is at issue is the nature of the politics at work in the thought and practice of the canonizing church.

We know very little about Maria Goretti. The story says that she was the daughter of a poor peasant farmer whose family shared a house with Giovanni Serenelli and his son Alessandro. Maria is said to have rejected the repeated advances of the sixteen-year-old Alessandro who made threats against her each time she refused him. Finally, fearful and

enraged by her rejection, Alessandro stabbed her repeatedly. She lingered for days. Before her death, it is reported that she forgave Alessandro.

During his thirty years in prison, Alessandro reported dreams in which Maria appeared to him and forgave him. Upon his release he is said to have sought out Maria's mother, begged her forgiveness and lived out his life in seclusion. Maria was canonized on 24 June 1950. The cause of her canonization was her willingness to die rather than be 'defiled' and her role in the conversion of her assailant.[5]

The canonization of Maria Goretti needs to be read in the context of nineteenth- and early twentieth-century papacies. The rationale for her sainthood developed in the tradition of these popes.

Two anti-patriarchal movements developed in the nineteenth century: political liberalism and feminism. Both redefined social problems in political and economic terms rather than in terms of personal morality. Feminism applied the principles of individual liberty to women.

Nineteenth-century feminists rejected the Common Law tradition that viewed society as a composite of free families in which the rights of individual men were protected from intervention by the state. Since women's roles were defined almost entirely in terms of family roles, the Common Law tradition placed the relationship between men and women outside the protection of law. Feminists insisted that the political and social empowerment of women would, of necessity, always involve issues of marriage, family life, sexuality and reproductive freedom.[6]

The papal response of the Roman Catholic Church to both of these movements was condemnation. Pius IX (1864–1878) reasserted the primacy of the church and the papacy in society (cf. *The Syllabus of Errors*). Leo XIII (1878–1903) rejected the definition of social problems in political and economic terms, insisting on the primacy of spiritual and religious values in the social order (cf. *Rerum Novarum* and *On Christian Marriage*). Pius X (1903–1914) insisted that the mission of the church was to maintain an unchanging order in both church and society (cf. *Lamentabili*). Benedict XV (1914–1922) reasserted the primacy of the church in the social order and blamed social unrest on the anti-authoritarianism of social movements (cf. *Ad Beatissima*). Pius XI (1922–1939) denounced the movement for women's emancipation as criminal and heretical (cf. *Casti Connubi*).

The canonization of Maria Goretti in 1950 was a culminating moment in this anti-modernist, anti-feminist papal tradition. Pius XII (1939–1958) insisted that the subordination of women to men was a dictum of the

natural law and, therefore, divinely intended. He espoused the identification of women with sexuality by insisting that women were created to fulfil sexual and reproductive roles (cf. *Papal Directives for the Woman of Today*).

The social control which the church sought, in the name of natural (divine) law, could not, by 1950, be established by recreating mediaeval theocracy. It could be exercised through the control of its members, who would be expected to conduct their personal and political lives in submission to the church. This authority had to extend to reproduction and the family, especially women, since the primary obligation of Catholic couples was to produce and raise new members of the church. Consistent with this view, Alessandro Serenelli's sin was not his attack on Maria Goretti. It was his attempt to engage in illicit sexual behaviour. Had Maria submitted in an attempt to save her life, she, too, would have been condemned.

Feminist reinterpretations of the sainthood of Maria Goretti

The papal tradition outlined above confronts contemporary Catholicism with a fundamental option. Will the church continue to see itself as the depository of correct thinking and behaviour? Or, will the church understand itself to need new perspectives, knowledge and skills as a participant in the struggle to realize greater freedom and justice in the world?

The Second Vatican Council reflects movement towards the latter. However, post-Vatican II Catholicism remains entrenched in patriarchal theocracy. Paul VI reduced priesthood to maleness and reiterated the teaching that women must be subject to male rule (cf. *The Declaration on The Ordination of Women*, *The Role of Women in Evangelization*, *Humanae Vitae* and *The Declaration on Sexual Ethics*). These positions continue to be offered as the true liberation of women. Feminist objections continue to meet condemnation. A church which excludes victims of oppression from efforts to overcome that oppression and persists in defining the ability to mediate God's presence on the basis of genetic chance and hormonal differences cannot possibly be participating fully in the liberating and saving work of God. A feminist reinterpretation of Maria's sainthood must critique the incompatibility of patriarchal theocracy and feminist commitment and establish the link between gospel values and anti-patriarchal feminist values.

For those persuaded by orthodoxy, the stories of the saints contain authoritative papal teaching which cannot be ignored. A feminist reinterpretation from this perspective would focus on the redemptive imagery used to convey the story of Maria's fidelity. Sin and evil are located in the disobedience of a world that has turned from its obligation to live in accord with God's intent as conveyed in church teaching. Grace and redemption (Alessandro's conversion) came into that world through Maria's act of obedience even unto death. The use of the biblical/ecclesial image of Jesus' own redemptive act, applied to Maria, portrays her as Jesus' representative in the on-going work of redemption. An orthodox feminist reinterpretation can offer this representation of Jesus by Maria Goretti as a challenge to the current position of Rome that women cannot be ordained because women cannot represent Christ on earth. Maria Goretti is pastoral testimony to the priesthood of women.

A second feminist reinterpretation of the sainthood of Maria Goretti sees the key pastoral moment as the affirmative act of rejecting the anti-feminist pastoral intent of her canonization. A true canonization of Maria Goretti by the faithful could rise from a refusal to accept her as anything other than a martyr to violence nurtured by a church which was willing to sacrifice the powerless in the name of its own patriarchal interests.

A feminist reinterpretation of the sainthood of Maria Goretti must offer a new image of the church, one which has within itself the capability of engaging competently and humbly with those who struggle against the forces of political and economic oppression. A new ecclesiology can develop out of the ministry of the faithful who voice the experiences of all victims of all forms of power-as-dominance.

A feminist reinterpretation of the sainthood of Maria Goretti that takes seriously the accounts of victims of gender-violence can imagine its way past the polemical portrayal of Maria Goretti to what her experience as a victim of attempted rape and murder might have been.

Maria's voice has long been lost to us. We can, however, try to imagine her anguish. Imagine the fear of a twelve-year-old child resisting unwanted advances and threatened death by someone with whom she lived. Imagine the struggle that enabled her to survive for however long. Imagine Maria screaming, begging and fighting against the force of her assailant. Imagine the possibility that for Maria, life was worth saving but that what she feared more than death was the certain rejection and peril she faced in a society that defined rape as a crime one man committed against another and in which rape could be used to force marriage. Imagine a society that renders

a child too frightened by social consequences to seek the protection of adults from threatened rape and death. Imagine a child too frightened by possible condemnation by her priest to seek his refuge. The world in which Maria struggled to survive promoted the belief that a woman was better dead than raped, and the church agreed.

Alessandro killed her because she refused to submit to him. The Roman Catholic church canonized her because she submitted to the higher authority of the church. Neither her attacker nor the church recognized Maria's right to decide her own fate. But perhaps Maria did.

Maria's sainthood rests in part on her forgiveness of her attacker. Maria did not urge him to seek out a priest for forgiveness. She forgave him. God did not send angels to a sleeping prisoner; Maria appeared to him and forgave him. Maria's acts of forgiveness reflect her own sense of oneness with God.

The 1950 canonization of Maria Goretti arose from the perspective and practice of a patriarchal, theocratic church. A feminist reinterpretation of the sainthood of Maria Goretti arises out of our individual and collective efforts to overcome the dehumanizing affects of patriarchy. That experience gives rise to a new vision of the church and to its redemptive mission. The voice we give to this martyred child is our own. The church we envision cannot understand the problems of violence and oppression or work to overcome them without the participation of its victims.

The stories about the saints function to hold up an ideal to which we can aspire. A feminist reinterpretation of the sainthood of Maria Goretti is an act of faithful imagination that rejects anti-feminist ecclesial practice as the norm for Christian self-understanding and, instead, identifies the gospel with an anti-patriarchal commitment. It functions not only as a critique of patriarchal theocracy but also as an affirmation of the new church now living in our midst. The ideal function of sainthood allows us to imagine what could have happened had this church been Maria's church.

Had the church lived in more solidarity with the poor and oppressed it could have condemned the attempted rape of Maria and her murder as further evidence of the violence to which women were repeatedly subjected. A church that rejected the abuse of power and aligned itself more consciously with the poor and oppressed could have condemned the poverty and special vulnerability of women in poverty that gave rise to such violence, then as now. A church confident in the presence of God could have re-examined its own views of sexuality, which associated force and sex. Instead, a theocratic church reasserted a patriarchal view of both

women and its own power-as-dominance which is, simply, another word for violence.[7]

Conclusion

Maria Goretti was a child murdered by another child. The reality of powerlessness and the cycle of violence it breeds is devastating. Every aspect of the future for which we bear full responsibility is challenged. The sacramental ministry of Roman Catholicism celebrates life at all stages; promotes the hope born in reconciliation, healing, and change; and affirms Christian vocation as a life-long commitment to justice, peace and love as gospel values. That Catholic-Christian vision to embrace the world with hope and skill is not contradicted by challenging patriarchal theocracy. That vision is affirmed as an ultimate act of faith and love.

Notes

1. M. Amir, *Patterns in Forcible Rape*, Chicago 1971.

2. P. L. N. Donat and J. D'Emilio, 'A Feminist Redefinition of Rape and Sexual Assault: Historical Foundations and Change', *Journal of Social Issues* 48.1, 1992, 9–22; D. Herman, 'The Rape Culture', in *Women: A Feminist Perspective*, ed. J. Freeman, California [2]1975.

3. J. D'Emilio and E. B. Freedman, *Intimate Matters: A History of Sexuality in America*, New York 1988; G. Lerner (ed.), *Black Women in White America*, New York 1973; K. Millet, *Sexual Politics*, New York 1970.

4. A. N. Groth and A. W. Burgess, 'Rape: A Sexual Deviation', *American Journal of Orthopsychiatry* XLVII (July 1977), 400–6; A. N. Groth, *Men Who Rape: The Psychology of the Offender*, New York 1979.

5. A. Butler, *The Lives of the Fathers*, ed. B. Kelly, Vol. V, Chicago 1956, 488–491.

6. S. B. Anthony, 'Social purity' (1875), in *Up From the Pedestal*, ed. A. S-D. Kraditor, New York 1975, 159–66; M. Wollstonecraft, *A Vindication of the Rights of Woman*, ed. M. Brody Krannick, Harmondsworth 1975, 24ff.

7. V. L. Erickson, 'Back to the Basics: Feminist Social Theory, Durkheim and Religion', *Journal of Feminist Studies in Religion*, 8.1, Spring 1992, 35–46.

Violence against Women: Strategies of Resistance and Sources of Healing in Christianity

Felisa Elizondo

An unhealed sore in society

The information collected by the Council of Europe for the Strasbourg Colloquium (1987) documents how various forms of violence persist in our countries although this sore is, to our shame, concealed, even by its victims. The phenomenon is difficult to quantify – the published cases represent no more than the tip of the iceberg – and takes the form of physical, mental, moral and sexual violence suffered by women with feelings of shame and guilt. It traps them and produces self-inflicted injury in two ways, in that the harassment, ill-treatment and humiliation is kept secret or is regarded as something belonging to the private sphere that cannot be talked about without indiscretion.

The result is that violence suffered within a family, or by a single woman who has to go through a painful procedure to make a complaint and bear the weight of opinion about 'her case', largely escapes prevention and remains out of reach of the various possibilities of help from other agencies. It slides out of the purchase of even adequate legislation, which in any case is slow in appearing. Nevertheless physical ill-treatment and humiliation produce serious traumas and leave after-effects on the women who suffer such aggression. For this reason resistance and attempts to eradicate aggressive behaviour are an urgent task within the defence of dignity and human rights.

Theological study cannot ignore this abuse, which, whether in the form

of rage, contempt or ill-treatment, today affects a considerable number of women. At the same time it must be recognized that this abuse, even before damaging women's bodies and even identities, degrades those who release their frustrations in this way, since such behaviour reveals a serious weakness beneath the blind fury. The violent act itself, as indicated by the profiles of those who behave in this way, is a confession and sign of personal imbalance, although it may be encouraged by external factors that prevention cannot ignore.

This ancestral suffering persists in the form of an obscure problem, concealed by an understandable shame in many cases and by defencelessness in others. It also continues because of the liberties the media take with the female body. The inherent aggressiveness in the human condition, together with the 'power' of the feminine in advertising, are turned into consumer objects in our societies, and the normal course of events would give the impression that violence is almost a cultural destiny.

And yet our analysis of this situation is not complete until we remember at the same time that attacks on personal dignity are felt, perhaps as never before, as real symptoms of cultural breakdown and a moral vacuum. Women are displaying their rejection of such outrages with unprecedented force, and this reaction deserves attention both because of its moral force and because of its potential to make the world more human.

Examination of conscience by the Christian tradition

I shall limit myself to a consideration of the undervaluing inherent in the violence that men release against women with worrying frequency. This devaluing of female identity inherent in the arrogance of violence must be condemned and dealt with in terms of basic convictions and the healing capacity of the Christian faith. This inheritance, which is a serious obstacle, must be brought to crisis point through our tradition. We must attempt to fill the vacuum of humanity represented by the acceptance of inquality, since it brings painful consequences, intended or not.

There is always a risk in reading the past with a sensibility remote from the period in question, but Christian history, reconsidered in this particular, can contribute a healthy self-criticism. Many studies produced by women in recent years have shown how an archaic mentality held back the innovating potential of Christianity. This is equivalent to admitting that Christianity has a 'debt outstanding to women', to apply Paul VI's remark to this case. Moreover, to recognize within history a long-standing

deficit in the consideration and valuing of the feminine helps to clear our vision for the task of looking for possibilities of halting or curing this insidiously lingering overhang of inhumanity.

Book IX of the *Confessions* contains Augustine's deeply felt memoir of his mother. At the same time the memoir reveals glimpses of a suffering that many women have experienced and accepted, like Monica, in silence, resigned to a predictable situation. This suffering did not escape her son's notice, though he does not seem to consider it exceptional (even in the sense of 'an exception'):

> . . . She was given in marriage to a man whom she served as her lord and tried to win him for you, speaking to him of you by her actions, by which you made her seem to her husband beautiful, worthy of reverent love and admiration. She put up with the insult of his infidelities, and never had the slightest quarrel with him over this, but waited for your mercy to come over him . . . Her husband was extremely affectionate but also extremely irascible, but she took care not to cross him when he was angry, not merely not by any action, but not even in speech. Only when she saw calm and quiet did she explain her actions, if he happened to have been unreasonably angry.

The rest of the passage shows that Monica had interiorized her subordinate state and the by no means infrequent violence of the time:

> When many matrons who had milder husbands than hers appeared with marks of beatings on their faces and began to complain about their husbands' behaviour in their chats, she . . . would tell them seriously, with the odd joke, that once they had heard the so-called marriage tablets read they should have considered them as a document that made them slaves of their husbands, and they should remember their status and not have thoughts of insubordination against their lords (*Confessions*, IX, 9).

To this picture of Monica's tact in avoiding such problems as could be avoided, Augustine adds a glowing portrait of a 'servant of the servants (of God)', faithful to one man, doing her duty to her parents, keeping house and speaking only through her work.

More than a thousand years after this memoir unquestioningly praising the ability to bear a state of inferiority and subjection with dignity and tact, a similar view was published. The author in this case was the Spanish humanist Luis Vives, who, in his *Instrucción de la mujer cristiana* (1528),

continues to uphold the idea of an unchangeable natural 'order' in marriage, together with his conviction that women are moral weaklings and inherently inferior to men. These presuppositions remain intact, leaving little room for women in this humanist's humanism.

In contrast to the 'vicious indulgence' of mothers who compliantly treat their children with 'gentleness' or 'excessive freedom' and indulgence, Vives praises the self-control of a mother who repressed her feelings:

> No mother ever loved her child more tenderly . . . She practically never smiled at me, never showed the slightest indulgence. And yet, once when I was absent from home for three days and she did not know where I was, she fell into a deep faint, and when I returned home I saw no sign that she had felt my absence.[1]

'Keep silent and suffer and refrain from any answer to a husband who is angry and irritable,' is the advice of this man who claims to entertain a 'sacred memory' of such a mother. I quote his language because it illustrates how natural domestic subjection and submission and the accompanying humiliation were considered for centuries:

> If he lays hands on you for some fault of yours or in a fit of madness, imagine that it is God who is punishing you, and that this is happening because of your sins, and that in this way you are doing penance for them. You are fortunate if, with a little suffering in this life, you gain remission of the torments of the next. In fact, very few good and prudent women are beaten by their husbands, however bad and mad they may be. Swallow your pain at home and do not prattle outside or to others about your complaints against your husband, lest you should seem to be asking for judgment between him and yourself. Shut domestic squabbles within the walls of your house, and do not let them escape into the street or run around the town. In this way your restraint will make your husband more restrained, whereas your complaints and offensive chatter would merely make him more and more incensed.[2]

An acceptance of the essential inferiority of women is at the root of these attitudes, which trivialize abusive behaviour in men and ignobly lay the blame on women. They dare to prohibit a legitimate reaction and recommend silence. They maintain the self-depreciation that paralyses women and lowers their self-esteem, and continue to present submission and dependence as part of the gender destiny of the 'daughters of Eve'.

This explains why one of the tasks undertaken by women with a special interest in the theology, spirituality, history, law or educational theory that draw on these sources is a revaluation sensitive to the contempt of women accepted or not sufficiently abjured by the Christian tradition.

This self-criticism affects the treatment of married life, the laws applied to it and the corresponding morality. It bears on the whole of Christian life, because morality, spirituality and ascetic theology have set up a more or less explicit sub-category of 'feminine' virtues that have done little to eliminate the subjection and internalized self-depreciation reflected in texts like the ones quoted.

The rediscovery of the unexplored potential of Christianity through such a self-criticism can reveal its inherent potential for liberation that must grow in this age of greater sensitivity to the cultural conditioning that has been able to reduce its force.

Submission in marriage

Mediaeval canonists and theologians – who took over the understanding of the feminine inherited from the Fathers and the scholarly authorities – did not stray far from what was accepted in their society. They did not presume to denounce the contradiction between the invariably admitted principle of 'equality in the Lord' and the use of language in connection with marriage that reproduced the model of master-slave, owner-property, command-obedience, leader-follower.[3]

This archaic attitude carried over from the Middle Ages to centuries and authors touched by the ideas of the Renaissance and Enlightenment. I noted this in referring to Vives, and much the same can be said of *La perfecta casada* of Fray Luis de León, one of the Castilian writers of the sixteenth century.

Even later educational writers persist in the belief that women's function and sphere is tied to the marriage and the family. The practice of keeping women uneducated, emphasizing 'womanly' frailty and superficiality, went hand in hand with the exaltation of uncritically accepted 'feminine virtues', oddly always reducible to 'honesty and discretion'.

Despite a few women who made their discomfort very clear, it is only in more recent times that educational writers criticize the ban on encouraging women to develop 'the enjoyment of intelligence as a relaxation from the often overwhelming material duties which burden them'.[4]

As late as *Character* and *Duty*, books widely read at the end of the

nineteenth century, we find that the best preparation of a woman for life is to develop 'her natural inheritance', visible 'in weakness, the need to look for support, to trust and be dependent, to reverence and serve' and 'in the strength that enables her to suffer, protect, defend and endure'. The author, a Scottish doctor with educational interests, continues his description of the natural feminine qualities with reference to adaptability, fortitude in the face of duty, dedication to others and devotion to her husband to ensure 'that his irritations and annoyances should be as few as possible'.[5]

Similar language can be found in the homiletics and educational writing of the twentieth century. Both genres often purvey the idea that constant service, forgetful of self to the point of abasement, is a vocation inherent in a woman's life, while no such considerations are applied to men.

Even tracts on married life published in the years approaching Vatican II are written in terms of greater tolerance for a husband's neglect of his duties and greater 'understanding' for his harshness or the excesses of his authority as 'head'. All this is based, sometimes explicitly, on the same view of women as more fragile and frail, totally corruptible, overwhelmed by her feelings and her heart, but with an intellectual and moral deficit. This portrayal leaves women excluded from the equality and real reciprocity that the best texts on marriage have called for since apostolic times.

A 'hierarchy in love', in the sense of 'a love that commands and a love that obeys', is accepted in the encyclical *Casti Connubii* (1930), which continues previous references in papal documents to authority in marriage. The near impossible recipe of 'a superiority that does not enslave and a subordination that does not humiliate' indicates a search for balance in some moralists, and in the post-conciliar period the standard definition of marriage in terms of 'a community of life and love' made it difficult at the same time to maintain the idea of submission.

Casti Connubii attempted to maintain an order, structure or fundamental law established by God that may not be disturbed while recognizing that submission must take different forms according to individuals and periods. Today anything that seems to detract from the fundamental equality and reciprocity of the couple is viewed with suspicion.

The currently dominant approach to marriage is personalist, regarding the free consent of the partner as the basis for a community that cannot be definied in hierarchical terms. The International Theological Commis-

sion's document on marriage says that marriage 'constitutes a setting and an environment conducive to the welfare of persons in accordance with their vocation', and 'can never be regarded as a means of sacrificing individuals to a common good extrinsic to them'.[6]

From 'feminine virtues' to virtue

The first strategy available to anyone wishing to get to the root of the violence still suffered by women is a condemnation of the role played in it by humiliating submission and degrading dependence. One of the roots of this violence is the belief, an unexamined premise, of women's inferiority or second-class status. This makes it essential to recover from oblivion and emphasize the inextinguishable dignity every women possesses as a person. No social organization can ignore this dignity, and no legal measure – civil or religious – can undermine it.

Religious writing has expatiated on the virtues that men – and the point of view is significant – have recognized in women: piety, managing a household, and an industriousness modelled on Martha, an amalgam of shyness, demureness and modesty to guarantee chastity or virginity, silence and discretion combined with abasement, and a peaceable disposition. An essential element, admitting of no exceptions, is a readiness to serve carried to the point of forgetting one's own existence.

It is enough to leaf through biographies, educational treatises or eulogies of Christian women to reconstruct, with slight variations, the picture sketched here, in which humility – and this shows its weakness as a virtue – is taken for granted or required, like obedience. A separate study would be required to analyse the priority enjoyed by female chastity or honour, which reflects a male projection and gives an indication of the way a woman's personality is treated as irrelevant when she is considered as a piece of property.

Such 'virtues', however, embody a considerable element of imposition – if only from the social pressure behind the models advocated – which makes it difficult to see the connection between them and personal freedom and conscience, the *sine qua non* of virtue as such. The insistence on the need to cultivate these virtues leaves little space for the core of the personality to be expressed in action. Virtues are reduced to tasks to be performed or duties to be accepted, a view remote from a creative conception of Christian living.

Separating humility from magnanimity has damaged both, and certainly

humility, which recovers its Christian roots only when it is not a model of behaviour or thinking defined by low self-esteem or a sense of unworthiness, but by truth, a general recognition of reality and confidence in personal possibilities that are not asserted with force or haughtiness, but backed by a courage that purifies and elevates them.[7]

Much the same could be said of the absence of any mention of women's dignity and freedom in their preparation for a life of service which is expected, if not an obligation. Neither this nor the so-called 'due' submission has much to do with the growth in freedom which accompanies true virtue, which cannot be reduced to imposed behaviour patterns that domesticate without liberating.

These reflections on Christian virtues bring them into relation with the core of the personality where freedom and intelligence develop their response to the call to live in harmony with the good and the true. Both have to be understood and assimilated personally if they are to be communicated. This call is always a free invitation to develop one's own personality in openness to other presences, in relationships which reflect and reinforce dignity.[8]

Moreover, service that is not rooted in freedom dishonours its own name and becomes servitude. Forced submission ceases to have the human quality which sets it apart from efficient functioning. To impose behaviour means to dehumanize it and deny that dignity which, even before it is expressed in particular behaviour, is the reflection of free will.

Conclusion

Returning to the subject, I wish to resist the indignity inflicted on women and affirm the personal worth of each woman, by questioning assumptions and exposing the consequences of a stubbornly maintained 'inferiority'. I do so by rescuing the feminine from reification, even at the level of women's bodies. I question the customary attribution of qualities and 'virtues', which still underlies, if no longer as blatantly as in other periods, some appeals to 'specifically feminine' attributes. The illegitimate use of the concepts of worth and virtue has contributed to a situation in which, by means of subjection and with the aid of silence or unconditional helpfulness, the preconception of inferiority or supposed weakness or inconstancy became labels attached to women for centuries.

To speak out and apply to women – not by implication but explicitly – the ideas about human dignity that have been developed in recent years, an

equally untouchable dignity that neither men nor women can surrender, is to talk about an untouchable core of personality and a physical integrity that no one may violate with impunity. It implies an existence that must be preserved from any form of violence because this damages the 'sacred human spark' that is personal dignity.

Of course the Christian tradition also teaches that evil casts its shadow over all periods. It cautions against the optimism that ignores its continuing threat in human relations and the interstices of love and emotion. One way of undercutting violence in its multiple forms can be seen in the forms of resistance and dissuasion used by pacifist movements on a geopolitical level. One way to cure violence at its root is to deny legitimacy to behaviour that encourages it and expose the false values that encourage its growth or deny its seriousness.

However, Christian wisdom also leads us to an understanding of the weakness inherent in the violent, which is not connivance in evil or lack of consideration for its victims, but an attitude of a piece with the realism that does not avoid predictable tensions, that does not rule out the appearance of this evil here and now. This clear-sightedness and strength has had notable exponents among women in sublime gestures of showing the 'gracious face' of forgiveness. This is not resignation to an intolerable situation but the 'strength of weakness' and a way of curing violence by defeating it with a desire for communion.

Translated by Francis McDonagh

Notes

1. Luis Vives, *Instrucción de la mujer cristiana*, Book 2, Ch. IX, *Obras Completas*, trans. L. Riber, Madrid 1947, 1099–1100.

2. Ibid., 1094.

3. Cf. M. Wade Labarde, *La mujer en la Edad Media*, Madrid 1986, 50–1.

4. Mgr Dupanloup, *La Educación de las hijas de familia*, trans. F. Navarro, Barcelona 1880, 64.

5. S. Smiles, quoted from the Spanish edition, *El Deber*, trans. G. Nuñez de Prado, Barcelona, n.d., 251.

6. Cf. J. Jacquemet, 'Femme', *Catholicisme* IV, Paris 1956, 1171–4; B. Häring, *La Ley de Cristo* II, Barcelona 1963, 146–7, 273–89 (ET *The Law of Christ*); M. Vidal, *Moral de actitudes* II/2. *Moral del amor y de la sexualidad*, Madrid 1991, 385ff.

7. Cf. D. Mongillo, 'Humildad', *Nuevo Diccionario de Espiritualidad*, Madrid 1983, 671–3; E. Kaczynsky, 'Humildad', *Nuevo Diccionario de Teología Moral*, Madrid 1992, 885.

8. Cf. D. Mongillo, 'Virtud', *Nuevo Diccionario de Teología Moral* (n. 7), 1871–91.

Clergy Misconduct: Sexual Abuse in the Ministerial Relationship

Marie M. Fortune

I Introduction

In the face of the continuing revelations of numerous cases of paedophilia committed by Roman Catholic priests in the US and Canada, the resignation of bishops and other prominent clergy from judicatories or local congregations faced with charges of ministerial misconduct involving sexual abuse of congregants, an increasing number of complaints brought against seminary faculty, and numerous complaints in every denomination, many ending in law suits, there can be no question that our religious institutions are in crisis. A secret long hidden has been disclosed and we face the challenge to respond in ways which can restore the integrity of the ministerial relationship.

If we fail in this challenge, our witness to a hurting world will be sorely compromised and our institutions may never recover from this crisis. We have the capacity to maintain institutional environments where persons who seek the resources of these institutions can expect to find help without being taken advantage of. This is the only way that we can provide a setting in which an individual's faith and/or intellectual gifts may flourish.

The problem of ministerial misconduct involving sexual abuse of congregants or clients is not new. Historical records of sometimes prominent clergymen describe what we now understand to be unethical and exploitative behaviour (e.g. Henry Ward Beecher in P. Hibben, *Henry Ward Beecher*, New York 1927). What is new is that many of those who have been victimized by the unethical behaviour of clergy and have survived are now coming forward to tell their stories and to seek redress.

Their candour and courage confront our religious institutions with a secret which has long undercut the credibility of all religious leaders: when some clergy in leadership cross the boundaries of the ministerial relationship and become sexually involved with congregants or clients, they betray the trust that is necessary for the minister to fulfil his/her calling.

This article will define and describe the problem of clergy misconduct involving sexual abuse and its consequences and will make a case for the importance of clear policy and standards in terms of the clergy's professional responsibility to those served.

From the perspective of the institutional church or synagogue which carries responsibility for the professional conduct of its clergy, the task is twofold: to maintain the integrity of the ministerial relationship and, in so doing, protect those persons who are vulnerable to clergy, i.e. congregants, clients, staff members, students, etc. – those who are vulnerable because of a variety of life circumstances.

II Scope of the problem

Ministerial violation of boundaries involving sexualization of a relationship takes place in the ministerial relationship or the counselling relationship, as well as the staff supervisory or mentor relationship. When the minister sexualizes the ministerial or counselling relationship, it is similar to the violation of the therapeutic relationship by a therapist. When the minister sexualizes the supervisory or mentor relationship with a staff member or student, it is similar to sexual harassment in the work-place, and the principles of work-place harassment apply. When a child or teenager is the object of the sexual contact, the situation is one of paedophilia or child sexual abuse, which is by definition not only unethical and abusive but criminal.

Sexual contact by ministers and pastoral counsellors with congregants/clients undercuts an otherwise effective pastoral relationship and violates the trust necessary in that relationship. It is not the sexual contact *per se* that is problematical but the fact that the sexual activity takes place within the pastoral relationship. The crossing of this particular boundary is significant because it sacrifices the ministerial relationship, and the potential harm that it causes is enormous.

The behaviours which occur in the sexual violation of boundaries include, but are not limited to, sexual comments or suggestions (jokes, innuendos, invitations, etc.), touching, fondling, seduction, kissing,

intercourse, molestation, rape, etc. There may be only one incident or a series of incidents or an ongoing intimate relationship over time.

Sexual contact by ministers or ministerial counsellors in ministerial, professional relationships is an instance of professional misconduct that is often minimized or ignored. It is not 'just an affair', although it may involve an on-going sexual relationship with a client or congregant. It is not merely adultery, although adultery may be a consequence if the minister/counsellor or congregant/client is in a committed relationship. It is not just a momentary lapse of judgment by the minister or counsellor. Often it is a recurring pattern of misuse of the ministerial role by a minister or counsellor who seems neither to comprehend nor to care about the damaging effects it may have on the congregant/client.

Actual research on clergy sexual involvement with congregants in the US is sparse. A 1984 study, however, provides some data: 12.67% of clergy surveyed reported that they had had sexual intercourse with a church member. In addition, 76.51% of clergy in this study reported that they knew of another minister who had had sexual intercourse with a church member (Blackmon, 1984). But the research which is most needed to give us a clear picture of the extent of this problem is a survey of the laity themselves.

Research on sexual harassment in the work-place of the church is also limited. In 1985, the United Church of Christ in the US asked its clergywomen if they had experienced sexual harassment in the church by senior ministers, supervisors, etc.: 47% responded affirmatively. A similar study done by the United Methodists in 1990 found 77% of clergywomen experiencing sexual harassment as staff members or students.

Cross-cultural data on the incidence of sexual abuse by clergy is anecdotal at this time. When I lectured in South Korea and the Philippines on violence against women early in 1992, the first and primary questions from the audience had to do with sexual abuse by clergy. My lecture as requested by the faculty at United Theological Seminary in Manila was specifically on the topic of clergy misconduct. My experience in the Netherlands in 1991 was very similar.

Although the vast majority of ministerial offenders in reported cases are heterosexual males and the vast majority of victims are heterosexual females, it is clear that neither gender nor sexual orientation excludes anyone from the risk of offending (ministers/counsellors) or from the possibility of being taken advantage of (congregants/clients) in the ministerial or counselling relationship.

III Consequences

The psychological effect on a congregant/client of sexual contact with their minister/counsellor is profound. Initially, the client/congregant may feel flattered by the special attention which feels positive and may even see her/himself as 'consenting' to the activity. Frequently, however, the congregant/client has sought ministerial care during a time of crisis and is very vulnerable. (It seems very common that persons who are exploited by a minister or pastoral counsellor have some history of childhood sexual abuse which may or may not have been addressed. Being a survivor of child sexual abuse only increases their vulnerability to further exploitation.) Eventually the congregant/client begins to realize that she/he is being denied a much-needed ministerial relationship and begins to feel taken advantage of. They feel betrayed, victimized, confused, embarrassed, fearful and blame themselves; at this point they are not likely to discuss this situation with anyone and so remain isolated. When anger finally surfaces, they are then ready to break the silence and take some action on their own behalf and on behalf of others.

Spiritually the consequences are also profound; the psychological pain is magnified and takes on cosmic proportions. Not only is the congregant/client betrayed by one representing God but also betrayed by God and the church or synagogue. For this person, the minister/counsellor is very powerful and can easily manipulate a victim not only psychologically but morally. The result is enormous confusion and guilt: 'But he said that love can never be wrong; that God had brought us together', or 'He said we should sin boldly so that grace might abound.' The psychological crisis becomes a crisis of faith; the stakes are very high.

IV An ethical analysis

It is a violation of professional ethics for any person in a ministerial role of leadership or ministerial counselling (clergy or lay) to engage in sexual contact or sexualized behaviour with a congregant, client, employee, student, etc. (adult, teen, or child) within the professional (ministerial or supervisory) relationship.

Why is it wrong for a minister to be sexual with someone whom he/she serves or supervises? It is wrong because sexual activity *in this context* is exploitative and abusive.

It is a violation of role. The ministerial relationship presupposes certain

role expectations. The minister/counsellor is expected to make available certain resources, talents, knowledge and expertise which will serve the best interest of the congregant, client, staff member, student intern, etc. Sexual contact is not part of the ministerial, professional role.

It is a misuse of authority and power. The role of minister/counsellor carries with it authority and power and the attendant responsibility to use this power to benefit the people who call upon the minister/counsellor for service. This power can easily be misused, as is the case when a minister/counsellor uses (intentionally or unintentionally) his/her authority to initiate or pursue sexual contact with a congregant, client, etc. Even if it is the congregant who sexualizes the relationship, it is still the minister/counsellor's responsibility to maintain the boundaries of the ministerial relationship and not pursue a sexual relationship.

It is taking advantage of vulnerability. The congregant, client, employee, student intern, etc. is by definition vulnerable to the minister/counsellor, i.e., in multiple ways she/he has fewer resources and less power than the minister/counsellor. When the minister/counsellor takes advantage of this vulnerability to gain sexual access to her/him, the minister/counsellor violates the mandate to protect the vulnerable from harm. The protection of the vulnerable is a practice which derives from the Jewish tradition of a hospitality code.

It is an absence of meaningful consent. Meaningful consent to sexual activity requires a context of not only choice but mutuality and equality; hence meaningful consent requires the absence of fear or the most subtle coercion. There is always an imbalance of power and thus inequality between the person in the ministerial role and those whom he/she serves or supervises. Even in the relationship between two persons who see themselves as 'consenting adults', the difference in role precludes the possibility of meaningful consent.

The summary of an ethical analysis of clergy sexualizing a ministerial relationship is the measure of harm caused by the betrayal of trust which is inherent in each of these four factors. Important boundaries within the ministerial or counselling relationship are crossed and, as a result, trust is betrayed. The sexual nature of this boundary violation is significant only in that the sexual context is one of great vulnerability and fragility for most people. However, the essential harm is that of betrayal of trust.

V A progress report

Survivors of sexual abuse by clergy began to disclose their experiences in the early 1980s. Since 1983, the Center for the Prevention of Sexual and Domestic Violence in Seattle, Washington, USA has been addressing the issue of professional ethics and sexual abuse by clergy. Between 1983 and 1993, the Center has had some contact with well over 1150 cases in the US and Canada. Center staff have served as advocate, minister or consultant with victims, survivors, offenders, judicatory and seminary adminis-trators, and lawyers.

In 1986, the first US conference on abuse in helping relationships was held in Minneapolis, Minnesota. Participants shared questions and strategies across professional disciplines. The title of the conference was significant: 'It's Never OK'. By the end of the conference, a subtitle was added: 'And It's Always Our Responsibility'. This is the bottom line – *and* it's never simple.

In 1989, *Is Nothing Sacred? When Sex Invades the Ministerial Relationship* was published. This book was the first critical appraisal of the violation of the ministerial relationship which named it an issue of professional ethics and sexual abuse.

The discussion of the problem has expanded; disclosures by victims/ survivors have increased; lawsuits against churches and synagogues, denominations, and pastoral counsellors have multiplied. A number of denominations at the national and regional levels are moving to develop policy and procedures, and they are being faced with an increasing number of complaints. More research projects are under way. Some attention is beginning to be focused at the seminary level of theological education on preparing ministers and pastoral counsellors to lessen their risk of violating the integrity of the ministerial relationship.

The good news is that *some* denominational leaders are moving swiftly and carefully to name the problem and to remove offending ministers in order to protect religious institutions from further harm and erosion of credibility. They also are moving effectively to bring healing to victims, survivors and congregations. The leadership which these persons are providing is significant and substantial. Careful, thoughtful, committed leadership is beginning to build a firm foundation for our religious institutions to fulfil their responsibilities. It is clear that education and preparation have empowered these leaders. But they remain few in number. And they run the risk of being marginalized for their actions.

However, in many quarters the resistance is strong to policies which state clear standards of professional conduct and to procedures which intervene to stop unprofessional conduct. The backlash is building. There are those who argue that setting limits on the sexual behaviour of someone in a professional role such as the ministry is anti-sexual and puritanical.

All of our efforts are played out against a backdrop of case after case being disclosed and adjudicated, often involving high profile religious leaders, including John Howard Yoder, a theologian and ethicist and member of the faculty at the University of Notre Dame; John Finch, a Christian psychologist who founded the School of Psychology at Fuller Theological Seminary in Pasadena, California; Notre Dame Provost James Tunstead Burtchaell, a Holy Cross Father and prominent theologian; and Archbishop Sanchez of New Mexico, who resigned facing charges of his ineffectual handling of paedophile priests in the diocese *and* of his own sexual abuse of young women during the past twenty years.

Although these cases and hundreds more like them are a painful reminder of the betrayal of trust by our leaders and of the unfinished business of rectifying these situations, they are also a witness to the fact that the church, synagogue and academy are beginning to deal with this problem of professional misconduct. Although every case brings pain and confusion, every case also brings an opportunity to make justice as a means to healing the brokenness.

But even in these efforts to address complaints, the results are mixed. Some judicatory administrators, although now informed and prepared with policy and procedures, are still not acting to stop offending ministers or pastoral counsellors.

In these situations, it would appear that the agenda which prevails is that it is the institution's mission to

– protect the perpetrator from the consequences of his/her behaviour
– keep the abusive behaviour a secret
– preserve the facade of pleasantness and normality in the institution.

The best example of this agenda occurs in cases where a victim of clergy professional misconduct finally sues the church, synagogue or seminary for damages. Frequently the institution, at the urging of its lawyers, has sought to settle out of court for significant sums of money *if* the victim(s) agrees to silence, i.e. not to discuss the particulars of her/his experience ever again. This institution is more interested in secrecy than justice and is willing to pay people off in order to preserve its public image.

The effect of this doctrine and practice is never healing but rather *de-evangelization*: people are leaving or being driven out of the congregation or seminary because of the professional misconduct of *some* of our clergy, teachers and pastoral counsellors and subsequent lack of response to their complaints. For these people, trust in religious leadership is for ever shattered. The credibility of these institutions is on the line.

Why in some quarters is there so little action? Why does it seem to be so difficult for judicatories or professional organizations to act swiftly and unequivocally on behalf of those harmed by offending ministers or pastoral counsellors? The short answer is a lack of will and even less courage.

The lack of will has to do primarily with an unwillingness to challenge the privilege of sexual access to congregants, staff and students which seems all too commonplace within a patriarchal institution. This traditional privilege has thrived within an all-male clergy which has been normative until relatively recently and which remains normative in many denominations today. It is no surprise that the disclosure of the sexual abuse of congregants (mostly women and children) coincides with the ordination of women in a number of Protestant denominations in recent years. The ordination of women has given women clergy a voice to speak of their own experiences of sexual abuse by religious leaders and has opened a door for lay women to come and tell their stories as well.

The lack of courage on the part of judicatory leaders has emerged in the face of legal anxieties: e.g. offending ministers may threaten to sue the church for slander, libel, or the loss of livelihood. These threats have in many cases halted disciplinary proceedings. Yet an offending minister has little basis on which to win such a suit.

Ironically it is another legal threat which may eventually embolden these institutions to act. In lieu of any effective action from their church, synagogue or denomination, many victims/survivors are turning to the courts for redress, for justice. People do not want to sue these institutions, but they will if they find themselves not only mistreated but stonewalled in their attempts to find justice.

Legally, the cost is high. The Roman Catholic Church in the US expects to spend $1 billion by the year 2000 in settlements for cases of professional misconduct by clergy (Stark, 'Child Sexual Abuse in the Catholic Church', in Schoener et al., *Psychotherapists' Sexual Involvement with Clients*, 1989). Recent US case law is unequivocal: the institution is responsible for the hiring and supervision of its personnel.

In his excellent article in *Christian Century*, Donald C. Clark Jr describes the move towards legal intervention in cases of professional misconduct by ministers. He also summarizes the legal system's response and asserts that 'the law is filling a void, a vacuum of leadership caused by the religious community's failure to act promptly and adequately . . . the law is doing what it historically does best: empower the powerless' (Clark, 'Sexual Abuse in the Church: the Law Steps In', *Christian Century*, 14 April 1993, Vol. 110, No. 12). He also rightly cautions the religious community not to allow its response to be directed by the lawyers: 'Justice must be the church's goal. But mimicking or accepting the legal definition of justice will not suffice.'

Development and consistent implementation of prevention and intervention strategies are fundamental steps towards maintaining the integrity of ministerial relationships. In short, the church, synagogue or denomination has the right and responsibility to remove ministers or pastoral counsellors who are a danger to the well-being of members or clients and the institution as a whole. The cost for *NOT* acting is enormous – morally, spiritually and legally.

But ultimately William White, author of *Incest in the Organization*, is correct when he observes that establishing policy and procedures is not going to solve this problem. It provides the mechanism, yes; but the commitment must be to a much broader and deeper change in our religious institutions. It will require a commitment to challenge the patriarchal core of our collective religious life where we have allowed religion to serve a patriarchal ideology and practice which has historically turned a deaf ear to the exploitation of women and children.

The progress reported here is the result primarily of the courage of survivors who have come forward and told their stories. These survivors, far more than judicatory administrators, committee members, or workshop leaders, have broken the silence which has allowed clergy and other ministers to misuse their religious offices for years. They have dared to speak the truth of their experience even, as the African-American poet and essayist Audre Lorde has said, 'at the risk of having it bruised or misunderstood'.

Survivors of abuse by clergy and other ministers have blessed the church and synagogue with the gift of truth-telling and deserve our gratitude. They have called us back to our mission: to name and confront the powers of evil within and among us, to work for justice, healing and wholeness of life.

N.B. This article is a revised and updated version of an article on clergy ethics which appeared in: *Sex and Religion: Religious Issues in Sexological Treatment/Sexological Issues in Pastoral Care*, ed. Jacques H. N. Kerssemakers, 1992.

Editorial Reflections

M. Shawn Copeland

This issue of *Concilium* opens the canon of anguish, examining violence against women. Violence is defined as 'rough or injurious physical force, action, or treatment'. Most basically, it is the coercive attempt to restrict, to limit, to thwart the exercise and realization of a human person's essential and effective freedom. Violence aims to obliterate the fundamental liberty or active, dynamic, determination of the self by the human subject. As the stories of abused and battered women recounted here attest, violence seeks to destroy not only the body, but the spirit as well. As a form of social oppression, violence is a structural or systemic phenomenon. However, as the feminist theorist Iris Marion Young argues, systemic violence is embedded in those unquestioned standards, symbols, habits, patterns and practices which compose a society or group, as well as in the epistemological, moral and religious assumptions which underlie not only the performance of prescribed social, cultural and religious roles and tasks, but also the individual and collective consequences of following (or not following) approved social, cultural and religious codes and rules. Hence, any individual act of violence against any woman is reinforced by the structural or systemic oppression of women as a group; and the structural or systemic oppression of all women as a group sanctions any individual act of violence against any woman. Structurally, then, violence permeates every sector of a woman's life: from waking to sleeping (and even during sleep), at work and school, in places of leisure and cultural refreshment, in restaurants and public parks, in concert halls and libraries, on the gynaecological table, on the therapist's couch, in the pastor's office, even, in her own home, a women is subject to physical, psychological, emotional, mental harassment, abuse and life-threatening danger. To be sure, it is no

longer possible to speak of women as if mere female embodiment erased an individual woman's social class, economic status, culture, ethnicity, race, religion, age, personal development, preference and geo-political positioning; yet, violence against women precisely disregards all these lines. And, to be sure, women who are members of oppressed social groups endure the intensifying marginalization of racism, of class exploitation, or of sexual orientation as well as the numbing refracted violence perpetrated against them by oppressed men. Still, given the hegemony – even mimetic – of patriarchal and (what Elisabeth Schüssler Fiorenza has aptly termed) kyriarchal power: women, individually and collectively, medically and spiritually, metaphorically and literally, live daily with the fear of violence.

Christian theological discussion and pastoral practice demonstrate considerable ambivalence toward violence. On the one side, Christianity employs a subtle intelligence in dealing with the social and political display of violence. Under certain carefully defined conditions, Christian tradition has tolerated and even sanctioned armed conflict between nations or political factions. Under certain carefully defined and other conditions, the tradition has condemned, if sometimes diffidently, armed conflict between nations or political factions, political repression and torture, genocide, chemical and bacteriological assault, the taking of hostages, and random bombings. Yet, and at the same time, the Christian tradition has promoted non-violence as both a universal principle and a strategy for achieving social justice – often, in the face of anarchical state terror. On the other side, while Christian pastoral practice reproaches acts of violence in the domain of private or personal relationships, it has tended to uphold non-violence as the ideal response. The response of the church to violence, then, is a contextual one, with the weight of interest on the side of social and political confrontation. This has had fatal consequences for women and children: the least powerful in every society, all too often, are enjoined to submit to violence in the domestic sphere, all too often in the name of the suffering and cross of Jesus Christ.

For more than thirty years now, feminist theologians and those who have affirmed and collaborated in their enterprise, have been calling upon the church in its theological and pastoral tasks critically to investigate the interrelations between and among religion, culture, gender construction and sexuality. That call reverberates graphically and poignantly in these pages. Drawing on the insights and analysis of our authors, these reflections put forward four pressing demands from among the many which women's experiences of violence justly place on the spiritual, moral

and intellectual resources of the Christian church. *First*, 'depth acknowledgment' of the church's own historic misogyny and ambivalent attitude towards and treatment of women. The church must confront not only its complicity in violence against women through silence or indifference, but its own wilful engagement in heinous acts of death-dealing. This 'depth acknowledgment' is to be followed by humble and critical self-examination, admission and confession of sin. This confession is to be followed by real repentance and firm purpose of amendment. Moreover, the church must provide a self-critical account of its acceptance of patriarchal and kyriarchal norms within ecclesial theological and pastoral traditions. Perhaps the relinquishment of these norms, prerogatives and privileges, so inimical to the gospel of Jesus, may come as a shock to those who cling to these forms of power, but the blood of raped, battered, abused and murdered women summons the church to its own *kenosis*. Thus, repentance and amendment are to be expressed in concrete healing actions which create, support and sustain real change. If the church is to be a credible, purified, authentic witness and servant of the message of Jesus, then, it must effect in its own life and structures what it preaches. *Second*, that *kenosis* ought to be conjoined to the development of a feminist theology of pastoral care which would seek out, receive, differentiate and cherish women's experience of *human being*. Such a feminist theology of pastoral care would empower the church to jettison that *aesthetic of submission* through which the central images, symbols, metaphors, narrative interpretations, traditions and rituals of Christian practice, explicitly and implicitly, coach and tame women to surrender to patriarchal and kyriarchal prerogatives and privilege. That theology would invite all women and men of good will *as ekklesia* to collaborate in advancing an *aesthetic of liberation* which would intentionally attentively, intelligently, rationally, responsibly and lovingly bring forth and test fresh images, symbols, metaphors, narrative interpretations, traditions and rituals for a non-oppressive, non-sexist truly human and Christian future. *Third*, critical reassessment and re-articulation of Christian theological anthropology is sorely needed. That reassessment might begin with a critical interrogation of the ways in which mass cultural production spawns ideology or planned conceptual and imaginal constructs that duplicate and enforce the very same culture (the *status quo*) that mass advertising creates; of the role and significance of religion within the resulting cultural matrix; and of the ways in which domestic relations are socially constructed and religiously reinforced and vice versa. That re-articulation

takes women's experience as *humans being women* as its starting point. That re-articulation analyses pornography – the ways in which it eroticizes the defacement of the *imago Dei* in women and deforms personhood in women as well as in men. Further, this analysis uncovers just how pornography distorts not only sexual expression, but the very nature of sexual desire and pleasure. Moreover, an adequate re-articulation of Christian theological anthropology in the light of women's experience rejects any tendency toward dualism or essentialism, while affirming human and cultural diversity. *Fourth*, clergy sexual misconduct has wounded most severely the integrity of the church's mission to care for souls. Women and children violated through this breach of trust in the ministerial relationship deserve nothing less than the fullest measure of the church's love and care. Indeed, pastoral care and concern as well as ecclesial authority must protect, support and render justice to the survivors of abuse. Church authorities must assume responsibility for the broken pastoral situation: providing counsel, direction and discipline to clergy who have been charged and adjudged as offenders; mediating repentance, forgiveness and justice for reconciliation. Through such a pastoral ministry, not only are the bodies of women and children restored to erotic and spiritual integrity, the very Body of Christ is restored to ontological and sacramental integrity.

Conversation between Jean-Bertrand Aristide, President of Haiti, and Dorothe Sölle, 2 September 1993

Sölle: The history of liberation movements in Latin America is one of blood and tears. I'm thinking of Chile and the murder of Allende in 1973 and the undermining and destruction of the Sandinista revolution in Nicaragua, and I fear that Cuba's days are numbered. What's different about Haiti?

Aristide: Our consciousness has deep roots. The rebellion of Toussaint L'Ouverture (1804) gained independence for an enslaved black nation. When this independence was lost, it was said: 'You have felled the tree of freedom.' However, the decisive thing was that the roots remained! It was impossible to tear them out . . . We now have two years of peaceful resistance behind us. Our consciousness is wide-ranging and strong. Our opponents thought that after a few months everything would be forgotten and that they could go on as they did before the first free elections in Haiti. They were wrong.

Chile and Cuba are different in having no diaspora abroad. 1.5 million Haitians live abroad, 100,000 of them in New York alone. They have helped us. They too have had enough of a system in which 7,000 soldiers claim forty per cent of the national budget.

Nicaragua won its victory in 1979 by force of arms, whereas our victory was won through a democratic election which no one challenged. For the first time in the history of our country the military came to grief in a *coup d'état*. They managed to arrange a *coup*, but they couldn't stabilize the economic situation.

Sölle: But will the upper class be happy for you to develop schools and health care for the poor? At present only one child in three goes to school.

Aristide: Those who rejected me need me now. The weapons of soldiers cannot make peace. No one feels safe; businesses don't prosper. Things were different in the first seven months of the democracy because there was political stability. Since the *coup* this stability has been destroyed. The military got money to commit acts of repression; they're asking for more and more money, but they can't achieve what the business world expects of them. Today, under the military *coup*, we have become the second largest trading centre for drugs.

Sölle: But isn't it true that the rich are afraid of you?

Aristide: They were afraid, but now they see that they have no alternative. The military aren't in a position to keep businesses going.

Sölle: Another question. Since the beginning of the 1990s there has been a new upsurge of cynicism, absolute individualism, hopelessness. A short while ago I was present at a conversation in the Netherlands between former friends of Nicaragua. They were unanimously of the opinion that it was wrong to give the Sandinistas a support which was starry-eyed and blind to reality. They gave me the impression that what they felt was, 'solidarity – never again', and, if there was to be any readiness to help, this would be only on an individual basis. Against this individualistic background, with its hostility to any utopia, I would like to ask you what keeps your hope alive.

Aristide: Our faith. Not a rational faith, but an experimental faith. We believe in people, men and women, in life, in God. As I said in the speech I gave in Aachen earlier this year, when I received the peace prize there: 'We live life; it is our greatest wish to make life worth living.' We live the faith of a prophetic people, driven on by the will to participate in democracy and make that participation possible for all. No matter what the price may be.

That's our experience, and we prefer to perish together than just to have success. It's like a marriage: two people marry and work together, care for each other and share their pleasures. We live out a similar social relationship: the mutuality is indivisible. There is misery, so we fight it together. Force prevails, so we fight it together. Our spirituality is the source of our hope, and the theology of liberation gives us this spiritual power.

Sölle: In your speech on receiving the Aachen peace prize you said two things which I haven't quite managed to connect. On the one hand you said that poverty has no religion. On the other, you mentioned as the only real danger the fact that we may cease to have faith, to have hope. I would very much like to know how you connect your hope with your Christian faith.

Aristide: When I returned from Israel I began to celebrate mass as a priest in a poor area. I had read in the gospel that we nourish the spirit when we nourish the body. Both together.

Then, when I began to fight against misery, the church suddenly became full of people with very different views: Catholics, Protestants, Voodoo adherents and people with no religion. We belonged together. We had a common devil. To this degree I think that misery has no religion, no confession, just as injustice has no religion either.

Sölle: But aren't we talking about two different forms of religion? Formal membership of a church, which you have just called 'rational religion', and a quite different relationship to life which is related to experience?

Aristide: The roots of this faith and hope lie in experience. I encounter my God through you. You are God for me: that is what makes religion dangerous for the powerful. I have heard God in my people of Haiti; the people teach me. It's like a big university!

Sölle: Can we also call this religion mystical?

Aristide: Certainly. I understand the two years of resistance among my people in terms of experience of this God. People who are being repressed, murdered, tortured, raped, exiled . . . they have fed me and supported me in my faith and my hope.

We are all Bosnians, Burmese, Cambodians, Haitians . . . how can I mentioned everyone? The people of Haiti continue to speak despite the gag which threatens to choke them. 'Man is born free yet everywhere is in chains.' It's two hundred years since Jean-Jacques Rousseau said that. The chains of slavery must now be broken. By the slaves themselves – each and every one.

The editors of the Special Column are Norbert Greinacher and Bas van Iersel. The content of the Special Column does not necessarily reflect the views of the Editorial Board of Concilium.

Contributors

JOANNE CARLSON BROWN, an ordained United Methodist minister, is currently Professor of Church History and Ecumenics at St Andrew's Theological College, a United Church of Canada Seminary, in Saskatoon, Saskatchewan, Canada. She received degrees from Mount Holyoke College, Garrett-Evangelical Theological Seminary and Boston University. She is co-editor with Carole Bohn of *Christianity, Patriarchy and Abuse: A Feminist Critique*, and has an essay in that book co-authored with Rebecca Parker, 'For God so Loved the World?'. In addition to this she has lectured and written numerous articles on church history and feminist theology, particularly in relation to theology and abuse.

Address: St Andrew's College, 1121 College Drive, Saskatoon, Saskatchewan, Canada S7N OW3.

ZILDA FERNANDES RIBEIRO was born in Goiás, Central Brazil. She is a Franciscan Sister of Pastoral Action. She holds master's degrees in dogmatic theology from the Pontifical Urban University in Rome and in philosophy of education from the Angelicum. She is Professor of Theology and Philosophy in the Catholic University of Goiás and the Goiás Institute of Theology and Philosophy. She has published articles on ethics and feminist theology in various journals since 1985. She is currently doing research and giving lectures and retreats on feminism in the Franciscan tradition, and preparing to defend her doctoral thesis on the theology of the body in the papal documents of John Paul II.

Address: Rua 222 no. 99, Setor Coimbra, CEP 74535–020, Goiânia, Goiás, Brazil.

BEATRIX SCHIELE is a Catholic theologian engaged in adult education; her scholarly interests are ethics and feminism, the politics of law and violence against women. Her publications include: 'Differenz und Solidarität im

europäischen Kontext', in *Feministische Theologie in Kontext Europas*, ed. L. Schottroff and A. Esser, Jahrbuch der Europäischen Gesellschaft theologische Forschung von Frauen 1, 1993; 'Lebensfülle für alle. Feministische Ethik zwischen den Lehrstühlen', *Jahrbuch christlichen Sozialwissenschaften*, ed. F. Fruger, 34, 1993, 214–32; 'Frauen und Männermoral. Überlegungen zu einer feministichen Ethik', in *Theologie feministisch. Disziplinen, Schwerpunkte, Richtungen*, ed. M. -T. Wacker, Düsseldorf 1988, 58–79; 'Feministische Ethik. Die Suche nach einer Moral für Frauen und ihre Mitmenschen', in *Handbuch feministische Theologie*, ed. M. Maassen and C. Schaumberger, Münster 1986, 362–73.

Address: Brahmsstrasse 4, D 72766 Reutlingen, Germany.

DELORES S. WILLIAMS is currently Associate Professor of Theology and Culture at Union Theological Seminary in New York. She is also a poet and short-story writer. Her most recent publication is a book entitled *Sisters in the Wilderness: The Challenge of Womanist God Talk*.

Address: Union Theological Seminary, 3041 Broadway, New York NY 10027, USA.

MARY JOHN MANANZAN OSB is the National Chairperson of Gabriela, a national federation of women's organizations. She is also the Dean of College of St Scholastica's College and Director of the Institute of Women's Studies. She is co-foundress of the Citizen's Alliance for Consumer Protection of which she is the present Secretary General, and the Center for Women's Resources, of which she is the present Chairperson of the Board of Advisers.

Address: St Scholastica's College, 2560 Leon Guinto Street, PO Box 3153, D–406 Manila, Philippines.

MARK TAYLOR is Associate Professor of Theology and Culture at Princeton Theological Seminary. He has two daughters and lives in Princeton, New Jersey. He is the author of *Beyond Explanation: Religious Dimensions in Cultural Anthropology*, Mercer, Ca. 1985; *Paul Tillich: Theologian of the Boundaries*, Philadelphia 1987, and, most recently, *Remembering Esperanza: A Cultural Political Theology for North American Praxis*, Maryknol!, NY 1990.

Address: Princeton Theological Seminary, CN 821 Princeton, NJ 08542–0803, USA.

IRMTRAUD FISCHER was born in Bad Aussee, and after training in education studied Catholic theology; she became an assistant in the Old Testament Institute in Granz and in the summer semester of 1993 was a visiting professor in Marburg. Her publications include *Wo ist Jahwe?*, SBB 19, Stuttgart 1989; *Untersuchungen zur theologischen Relevanz der Frauentexte in den Erzeltern-Erzählungen*, Graz 1994 (in preparation), together with a number of articles on biblical texts concerned with women's and feminist questions in the 'Graz Project for Interdisciplinary Women's Studies'.

Address: Parkstrasse 1, A – 8010 Graz, Austria.

E. ANN MATTER is Professor and Chair of the Department of Religious Studies at the University of Pennsylvania in Philadelphia. She received degrees in Religious Studies from Oberlin College and Yale University. Her publications include a critical edition of Paschasius Radbertus, *De partu Virginis*, in the Corpus Christianorum, Series Latina, Turnhout 1985, and *The Voice of my Beloved: The Song of Songs in Western Medieval Christianity*, Philadelphia 1990. She is co-editor (with John Coakley) of *Creative Women in Medieval and Early Modern Italy: A Religious and Artistic Renaissance*, Philadelphia 1994 (forthcoming); is part of the international team researching the commentary tradition of the *Glossa ordinaria*; and is finishing work on a book about Maria Domitilla Galluzzi, a seventeenth-century visionary of Pavia, Italy.

Address: Department of Religious Studies, University of Pennsylvania, Box 36 College Hall, Philadelphia PA 19104, USA.

EILEEN STENZEL received a PhD in Theology from the University of Notre Dame and an MA in Counselor Education from The University of South Florida. She has taught Theology, Religious Education and Women's Studies, and has experience in career counselling with women, rape crisis counselling, and addiction and co-dependency recovery. She is the author of 'Recovery from Addiction', *Human Development*, IX(4), 1988, 6–13. Work-in-progress includes a book on theological skills for pastoral counsellors.

Address: 10624 S. La Crosse, Oak Lawn, IL 50453, USA.

FELISA ELIZONDO has first degrees in philosophy and letters (classics) and a doctorate in theology. She is Professor of Theological Anthropology in the Instituto Superior de Pastoral (Madrid) of the Pontifical University of Salamanca (Spain). She is a member of the European Association of Catholic Theologians and of the Spanish Theological Association. She is coordinator of the 'Anthropology and Feminism' seminar of the Instituto 'Fe y Secularidad' in Madrid. Among her writings are the book *Conocer por experiencia. Un estudio sobre sus modos y valoración en la Suma Teológica*, Madrid 1992, and the articles 'La "otra voz" de la Teología', *Sal Terrae* 3, 1993, and 'Lo feminino y el Misterio trinitario', *Estudios Trinitarios* 2, 1993.

Address: Isaac Peral 60, 28040 Madrid, Spain.

MARIE M. FORTUNE grew up in North Carolina, where she received her undergraduate degree from Duke University. She received her seminary training at Yale Divinity School and was ordained a minister in the United Church of Christ in 1976. After serving in a local parish, she founded the Center for the Prevention of Sexual and Domestic Violence in Seattle, Washington where she serves as Executive Director. She is the author of: *Is Nothing Sacred? When Sex Invades the Pastoral Relationship*, San Francisco 1989; *Keeping the Faith: Questions and Answers for Abused Women*, San Francisco 1987; *Sexual Violence: The Unmentionable Sin*, Cleveland, Oh, 1983, and other books and articles.

Address: Center for the Prevention of Sexual and Domestic Violence, 1914 North 34th Street, Suite 105, Seattle, Washington 98103 USA.

Directors/Consellors–cont.

Dietmar Mieth	Tübingen	Germany
Jürgen Moltmann	Tübingen	Germany
Aloysius Pieris SJ	Gonawala-Kelaniya	Sri Lanka
James Provost	Washington, DC	USA
Edward Schillebeeckx	Nijmegen	The Netherlands
Cristoph Theobald SJ	Paris	France
Miklós Tomka	Budapest	Hungary
David Tracy	Chicago, IL	USA
Marciano Vidal CSSR	Madrid	Spain
Knut Walf	Nijmegen	The Netherlands
Christos Yannaras	Athens	Greece

General Secretariat: Prins Bernardstraat 2, 6521 AB Nijmegen, The Netherlands
Manager: Mrs E. C. Duindam-Deckers

Members of the Advisory Committee for Feminist Theology

Directors

Mary Shawn Copeland	New Haven, CT	USA
Elisabeth Schüssler Fiorenza	Cambridge, MA	USA

Members

Kari Børresen	Oslo	Norway
Bernadette Brooten	Cambridge, MA	USA
Anne Carr	Chicago, IL	USA
Mary Collins OSB	Washington, DC	USA
Monique Dumais	Rimouski, Quebec	Canada
Marita Estor	Bonn	Germany
Toinette Eugene	Rochester, NY	USA
Margaret Farley	New Haven, CT	USA
Ivone Gebara	Recife	Brazil
Catharina Halkes	Nijmegen	The Netherlands
Mary Hunt	Silver Spring, MD	USA
Marianne Katoppo	Jakarta Pusat	Indonesia
Ursula King	Bristol	Great Britain
Alice Laffey	Worcester, MA	USA
Denise Lardner Carmody	Tulsa, OK	USA
Mary-John Mananzan	Manila	Philippines
Elisabeth Moltmann-Wendel	Tübingen	Germany
Jaime Phelps OP	Washington, DC	USA
Judith Plaskow	Bronx, NY	USA
Marjorie Procter-Smith	Dallas, TX	USA
Ida Raming	Greven-Gimbte	Germany
Rosemary Radford Ruether	Evanston, IL	USA
Christian Schaumberger	Kassel	Germany
Sandra Schneiders IHM	Berkeley, CA	USA
Helen Schüngel-Straumann	Kassel	Germany
Elsa Tamez	San José	Costa Rica
Beverly Wildung Harrison	New York, NY	USA

Concilium Subscription Information - outside North America

Individual Annual Subscription (six issues): £30.00

Institution Annual Subscription (six issues): £40.00

Airmail subscriptions: add £10.00

Individual issues: £8.95 each

New subscribers please return this form:
for a two-year subscription, double the appropriate rate

(for individuals) £30.00 (1/2 years)

(for institutions) £40.00 (1/2 years)

Airmail postage
outside Europe +£10.00 (1/2 years)

Total

I wish to subscribe for one/two years as an individual/institution
(delete as appropriate)

Name/Institution .

Address .

. .

. .

I enclose a cheque for payable to SCM Press Ltd

Please charge my Access/Visa/Mastercard no.

Signature .Expiry Date

Please return this form to:
SCM PRESS LTD 26-30 Tottenham Road, London N1 4BZ